detail of **Avalon** 1984

Stephen

Published 1985 by the Museum of Modern Art Oxford and the Walker Art Gallery Liverpool to accompany the exhibition **Stephen Buckley: Many Angles** organised with subsidy from the Arts Council of Great Britain

ISBN 0 905836 49 9

● *Tour dates:*
Museum of Modern Art Oxford 14 April-2 June 1985
Arts Council of Northern Ireland Gallery Belfast 4 July-3 August 1985
Walker Art Gallery Liverpool 30 August-6 October 1985

© Museum of Modern Art Oxford and Walker Art Gallery 1985
Text © Marco Livingstone
Reproductions © Stephen Buckley except as noted

● *Exhibition*
organised by Marco Livingstone for the Museum of Modern Art and Walker Art Gallery
assisted by Ingrid Swenson and Paul Bonaventura

● *Book*
edited by **Marco Livingstone**
designed by **Neville Brody** and **Robin Derrick**
printed by the **Journeyman Press, London**
distributed by **Thames and Hudson Ltd., London**
photoset in Gill Medium, Bold and Extra Bold
printed on 170gsm matt art paper
cover printed on 383gsm white-lined chipboard

A list of all Museum of Modern Art publications in print can be obtained from the bookshop manager at the Museum of Modern Art, 30 Pembroke Street, Oxford OX1 1BP.

Photography credits
Prudence Cuming Associates, London
John Webb Photography, London
Langen, Wind & Norman, London
John Mills Photography, Liverpool
Arts Council of Great Britain
Tate Gallery, London
courtesy the artist
courtesy Saatchi and Saatchi Company

Reproduction Acknowledgements

Richard Hamilton
Howard Hodgkin
Neue Pinacothek, Munich
J. Sainsbury plc
Richard Smith
Tate Gallery Publications Department

Buckley

MANY ANGLES

● **Marco Livingstone**

The explanatory notes accompanying captions to the reproductions are by the artist. Dimensions are listed both in inches and in centimetres, height by width.

Preface

WITHDRAWN

Stephen Buckley's work had a great impact when it first appeared in the late 1960s, especially on young artists, for its vigorous challenge to the conventions of painting at a time when the future of the medium itself appeared to be under threat. Unperturbed by the idea of finding his own way whatever the current fashion, Buckley never lost faith in his solutions, even though he was acutely aware of the extent to which his art went against the grain of the Minimalism, Conceptual Art and photo-text work of the 1970s. It was perhaps the single-mindedness of his stance, combined with the sensuous appeal of his work in a period of almost puritanical stringency, that made him something of a hero in the mid-1970s. Since then, other types of painting have come back into favour with a vengeance, yet because Buckley's work wears neither its expressiveness nor its referential subject matter so obviously on its sleeve, it remains as aloof as ever from the vagaries of fashion. With two decades of solid achievement behind him, Buckley no longer seems the wild man, and with critical attention having shifted to the dazzling, if in some cases superficial, attractions of the art world's newest stars, this seems an appropriate moment to assess the contribution of one of Britain's most uncompromising abstract painters.

The two organising institutions have a particularly close relationship with the artist. It was at the Walker Art Gallery in 1974 that Buckley was awarded a prize in the John Moores Liverpool Exhibition, the biennial competition of British painting for which he was to serve as a jury member in 1982 and in which he was awarded a major prize in March of this year; the Walker was also one of the first public institutions to purchase one of his paintings. It was, moreover, a decade ago that the Museum of Modern Art hosted an impressive one-man exhibition which did much to seal the artist's reputation in this country. It is thus with a special pleasure that we welcome back Stephen Buckley and thank him for the immense energy and commitment with which he has supported this project.

John Kasmin of Knoedler Kasmin Ltd., who has enthusiastically served as the artist's dealer since 1972, has played a major role not only through the generosity of his loans but also in his assistance in securing other works and in his contribution towards the colour reproductions in this accompanying monograph. With the exception of one early work lent by the artist's New York agent, Brooke Alexander, all paintings have been drawn from private and public collections in the UK, including the Tate Gallery, which has generously lent three works to the tour. Few pictures from 1979/80 remain in this country, but all other periods of the artist's production, which now encompasses more than 350 paintings, are represented here by key works, thanks to the support of the many lenders listed separately.

We wish to express our appreciation to the Arts Council of Great Britain for their generous support of the exhibition's tour, to Thames and Hudson Ltd., for distributing this monograph, and to Nikos Stangos for his close reading of the text and helpful suggestions.

Marco Livingstone, Deputy Director, Museum of Modern Art, Oxford.
Timothy Stevens, Director, Walker Art Gallery, Liverpool.

Stephen Buckley

So many angles of approach are offered by Stephen Buckley's paintings that one is hard-pressed to decide where to begin. Most critics have chosen to describe the numerous processes of which the artist has availed himself in fabricating his works, seeking to re-make or re-model these actions by translating them into words. Such verbal descriptions inevitably offer only a pale substitute for an unravelling of procedures which are self-evident when one is confronted by the object itself. Buckley's titles, likewise, may seem to provide a convenient basis for interpretation, but it is best to use these with caution until one has entered into the spirit of the work. To begin with the frequent allusions to familiar objects and places or to the work of other twentieth century artists, is, however, to leave oneself open to the possibility of being led astray, given that the connections can be tenuous and that the artist sometimes intends them not as guides to 'meaning' but as useful starting-points for making a painting.

To follow any one line of investigation to the exclusion of the others would be foolhardy. We could talk ourselves to death but I believe, in the end, we would only waste our breath because Buckley is a shameless plunderer and a tease. He is in the habit, it is true, of revealing explicitly in the work itself the steps he has taken in putting a painting together, often exposing the support to which the paint has been applied and even presenting as graphic devices the actual fixings which hold the object together or which allow it to be hung on the wall. To make sure that his audience is paying close attention, he will follow such candid self-exposure with a substitution of method so subtly different as to border on the devious. What functions in one work as a helpful hint can as easily turn into a wild goose chase in the next, as happens, too, with his use of suggestive titles and visual references. There is a mischievous delight bordering on the wilful and perverse in this constant game of hide-and-seek, of revelation and concealment.

On the surface Buckley's work appears to be matter-of-fact, self-evident. Attention is drawn so forcefully in the first instance to the properties of the paintings as objects — constructions that have been assembled and then covered by layers of paint and other, less conventional, colourants — that it would be fair to assume that their only graspable reality is that of their physical existence. As soon, however, as we begin to appreciate that a thread of metaphor and allusion is as much of a binding agent as any of the artist's materials, it becomes evident that the areas of emotion and experience on which he has drawn are available to us, too. The choice is left to us whether to remain passive spectators, enjoying the paintings as decorations — a fair enough option — or to become more actively involved by engaging with the emotional and mental processes which together have tempered and influenced the physical actions which have produced the final work.

One of the rallying cries of abstract painters in the 1960s and through into the 1970s was the dictum of American artist Frank Stella that 'what you see is what you see'. An equally prevalent

5

notion, likewise inherited from the nineteenth century invention of 'art for art's sake', was that of 'art about art'. As an admirer of Stella's work and as an astute and informed observer of contemporary developments and of the history of twentieth century art, Buckley, even as a young student in the mid-1960s, was quick to appreciate the attraction of both courses of action. He also recognised, however, that there were dangers in an excessive emphasis on self-justifying fact in the case of abstract art solely concerned with exposing its own condition, and in the tendency to inwardness and aesthetic narcissism of 'art about art'. To a painter like Buckley, who stoutly maintains that he had recognised his vocation at the age of three and a half, making pictures has always seemed such a natural activity, such an integral part of his life, that to limit its audience to a self-congratulatory circle of well-versed participants would be in some way to betray its very purpose. It is for this reason that Buckley, while using a visual language of great simplicity and directness, has consistently maintained referential links in his work.

Keen though he has always been to make work that is as accessible to the layman as to the most knowledgeable specialist, Buckley, like many artists, has always been loath to explain his intentions or to produce verbal justifications of his art. In the few talks which he has given, usually in an art school context, he has limited himself largely to describing the processes by which he has made particular paintings. He balks at requests for written statements and in fifteen years as an exhibiting artist he has granted only two published interviews prior to the discussions which preceded the present study.[1] Given the open-endedness of Buckley's work and the misinterpretations which have been advanced over the years, such reticence on the part of an otherwise highly sociable and articulate man might appear hard to fathom. It is all the more remarkable when one considers the obsession with theory and correctness of interpretation which has marked so many artists of his generation. It was, however, precisely because so many of his colleagues sought to direct the response to their work and to ensure its intellectual respectability through the clarity of its logic that Buckley has remained, until now, so tight-lipped.

'It does seem to me that a huge number of artists that have to talk about their work and want to verbalise it are longing for some sort of academic respectability. They're longing to be recognised for their intelligence, rather than having confidence in that thing that they've produced. And I think that is why one may have always been slightly taciturn about questions. It seems to me that what you make is really the important thing.' Buckley explains that even in his discussions with fellow artists and close friends, 'it's what you *don't* say that counts, what you *omit* that is immediately understood by the other person.'

Buckley's paintings, in spite of the artist's own reluctance to discuss them, lend themselves easily to close analysis, particularly in terms of the procedures by which they are made. Pleasurable as it is to reconstruct the artist's actions when confronted by the painting, such detailed descriptions, when foisted upon you, seem remarkably dry and ponderous, draining the pictures of their vitality. The satisfaction of working things out for yourself is as important in looking at a Buckley painting as it is when reading a detective story. The brief comments by the artist which accompany many of the illustrations in this book are thus intended not as explanations but as clues to their methods of construction, useful insofar as much of the evidence visible in the works themselves is lost in reproduction.

The personal background recounted in the pages that follow is presented neither as a substitute for critical analysis nor as a means of 'explaining' the work. Buckley's paintings are not directly autobiographical, but in distinction to the work of other abstract artists, they *do* bear strong traces of his personality, of the circumstances of his life, and of his interests. All this is evident in the pictures themselves, especially in their 'do-it-yourself' aspect: along with traditional artists' materials such as canvas and oil and acrylic paints, Buckley has made use of such ordinary substances as housepaint, shoe polish, liquid linoleum, plexiglass, carpeting and old clothes; he has not only painted with conventional brushes on stretched canvas, but has frequently used processes such as tearing, folding, stitching, stapling, patching, screwing together, nailing and weaving. In their subject matter, too, the paintings often make reference to things familiar from our everyday environment: in the early work to crazy pavings, tartan patterns and prosaic interiors, in more recent cases to more specifically-rooted architectural details and in the use of cardboard tubing and drain pipes as constructional elements.

'All these things,' Buckley agrees, 'are things I like. They're things I enjoy in everyday habits and things that I notice, see and am curious about. I see no difference in using these things and people making a still life: you're choosing what you're going to make a still life out of, or choosing what you're going to photograph, or choosing the landscape that you're going to paint. I think it's the same thing, just done in a different way.'

If Buckley's paintings often seem crude and ramshackle in their construction, the work of an enthusiastic handyman rather than of a refined craftsman, this is a deliberate choice rather than the result of hamfistedness. Their very imperfection and roughness, like the decision to allow mistakes or changes of mind to show through, become signs of the artist's vulnerability. So much is revealed within the paintings themselves of their mode of construction and of the decisions and attitudes which have gone into their making that they become humanised; rather than being confronted with a finished object that has been produced through an intellectual process, one is encouraged to speculate on the course the artist has taken and, in so doing, to identify with him.

'I always assumed that I was going to be an artist,' explains Buckley, 'right from the beginning.' From an early age he was aware that he had a facility for drawing, and he received particu-

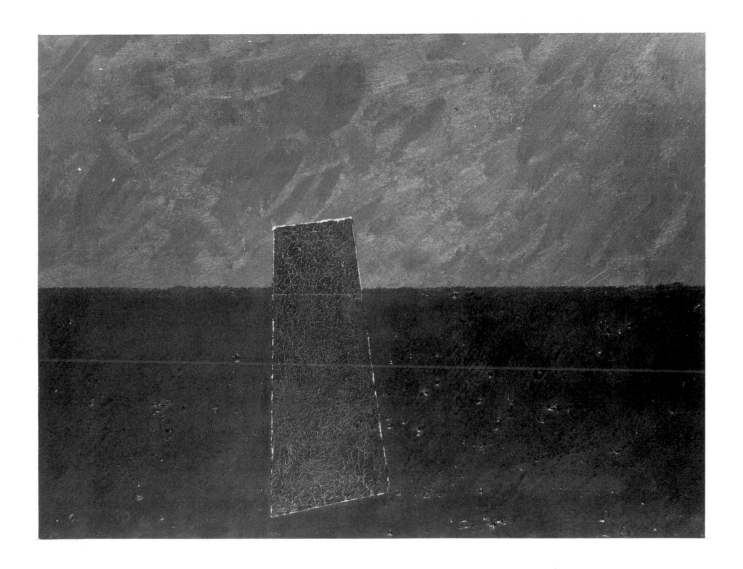

● **Untitled** *1967*
oil and enamel on canvas 18 × 24 (46 ×
61) Nikos Stangos and David Plante *cat. 2*

Some sort of isolated architectural element.

● **Dos** *1968*
wax encaustic and metal enamelled with
bandages 26 × 27 (66 × 68.5)
The artist *cat. 3*

The bandages hide the crude carpentry of an *ad hoc* Oxford frame. Thinking of the 1914-1918 war, 'Dos' initially referred to John Dos Passos (reading him at the time) and then bones, back, back to front etc.

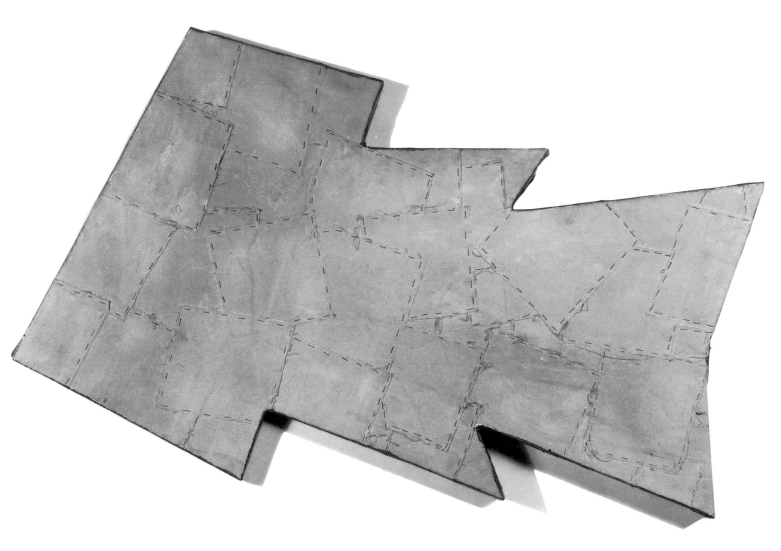

● **Höch** *1968*
*varnished canvas on wood 29 × 46 (73.5 ×
117)* Max Gordon *cat. 4*

The stapled squares reminded me of a painting
of a tapestry by Hannah Höch.

9

lar encouragement when he was in the fifth and sixth form of his school in Leicester by a newly-arrived art teacher, William Varley. It was on the recommendation of Varley, a native of Tyneside, that Buckley decided to apply for a place in the Fine Art Department of the University of Newcastle, where he began his studies in the autumn of 1962 at the age of eighteen.

At home Buckley met no opposition to his decision to train as an artist, though his father, a junior school teacher who also taught music, was of the opinion that he should also obtain a teaching certificate so that he would have something to fall back on if necessary. His mother had worked before the War as a designer and pattern-cutter in hosiery. Buckley discounts the possibility of a connection between his mother's work and the references in his paintings to textile patterns, weaving and stitching, pointing instead to the fact that his wife, Stephanie James, whom he met at the end of 1971, is herself a designer and maker of clothes; the fact remains, however, that such allusions appear in his pictures as early as **Toni's Restaurant** in 1969. As a child he remembers reproductions of paintings by van Gogh and Vermeer in his home, as well as coloured prints of twentieth century artists such as Franz Marc which were standard features of the classrooms of state schools in Leicester. The Leicester Museum and Art Gallery was also a vital part of his education, with the mummies in the Egyptian section and paintings by Frith and Robert Bevan making a particular impression on him. The collection there of German Expressionist paintings, unique among British provincial galleries, both intrigued and confused him, though he was open to new discoveries. 'Quite early on I became very keen on Matthew Smith.' There was a very luxurious nude there which didn't disturb me, which I completely accepted early on as a good way of painting.'

As a boy Buckley was taught the rudiments of a number of musical instruments by his father, but he had neither the patience nor, he implies, the co-ordination — 'I am totally right-handed' — to learn how to play any of them properly. Music has nevertheless been of continuing interest to him and has supplied him with subject matter and imagery in paintings such as **Jazz** (1971) and a group of canvases in the early 1980s which included **Béla** and **With Pipes and Drums**, both dedicated to the Hungarian composer Béla Bartók.

Theatre was of interest to Buckley from an early age, leading him to join the drama group at school, with which he made his first visits to Germany in touring productions of **Henry IV Part 2** and **A Midsummer Night's Dream**. At about the age of sixteen he became friendly with a French assistant at the school, Claude Duneton, who shared his enthusiasm for the stage. Together they introduced themselves to the management of the newly-formed Living Theatre set up in Leicester in a converted chapel by William Hayes, Jill Gascoigne and Derrick Goodwyn. For two years Buckley helped in whatever way he could, largely on a voluntary basis and in his spare time, initially on stage management, selling ice creams and the like, but moving on to the production of sets after the departure of the man initially

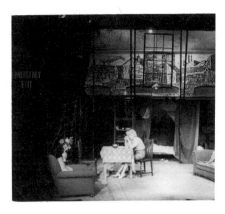

Stage production of **A Taste of Honey** at The Living Theatre, Leicester, 1962, with set by Stephen Buckley.

charged with that responsiblity. Buckley produced sets for six productions — **Fairy Tales of New York, A Taste of Honey, Roots,** the first repertory production of **Luther, The Taming of the Shrew,** and **The Knack** — and also designed and made props, with the help of the stage manager, for reviews and other productions. The plays were performed either in ordinary modern dress or in hired costumes, and only on one occasion did Buckley make a painted backdrop: a simplified cityscape for **A Taste of Honey**, painted directly on the wall in a style which owed something to one of the few contemporary artists of whom he was then aware, Bernard Buffet. Speed was of the essence, as one play would finish its run on a Saturday and the dress rehearsal for the next would begin on the Monday morning. Quite often furniture and other props would find their way from one production to the next. Buckley is cautious not to overestimate the influence of this experience on his later painting, which has likewise been characterised by recycling habits and by a willingness to improvise from whatever is to hand, but admits that it confirmed his confidence in his creative talents: 'I think what it did mean is that I knew I had the ability to make things or adjust things. I knew I had the ability to make do.'

Buckley's decision to go to Newcastle University rather than to an art school was determined to a certain extent by the fact that as a course leading to a B.A., rather than to the National Diploma in Design, it qualified him for a full grant which allowed him to move away from home; leaving Leicester, he says, was half the point. Once settled in, however, he quickly realised how fortunate he was to have as his teacher Richard Hamilton right at the time that Pop Art was in its ascendancy. 'A student tends to make work that is like what is current at the time or that is like the work of the teacher he admires,' points out Buckley, who discovered while he was still in his late 'teens that he was 'instinctively interested in that thing called taste, urban develop-

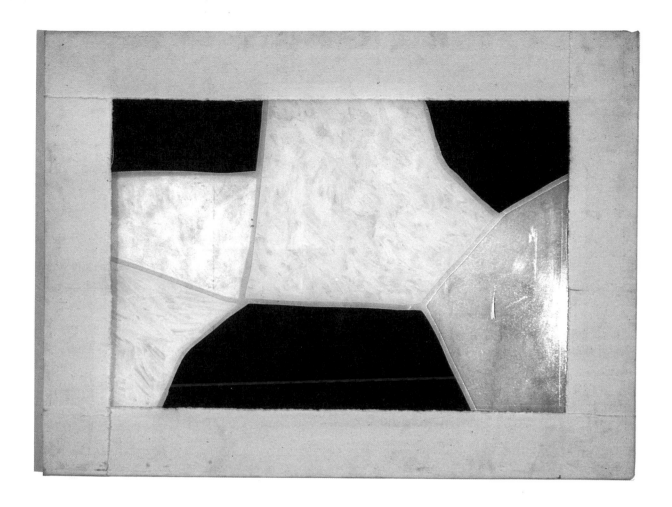

● **Crazy Paving** *1968*
oil on plexiglass 36 × 48 (91.5 × 122)
David Hockney *cat. 5*

One of a series of crazy paving paintings. The coloured areas are painted on the reverse of the plastic, which is thickly varnished on the front.

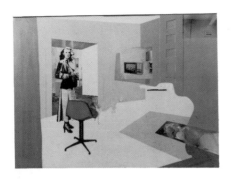

Richard Hamilton. **Interior II** 1964. Oil, collage, cellulose, metal relief on panel 122 × 162.5 cm. Trustees of the Tate Gallery.

ment and the lives we live.' Hamilton, though rather reclusive when working, did allow students into his studio at the university, and it is clear that works such as the **Interior** series on which he was occupied in 1964 struck a particular chord with Buckley as a young art student.

'Those early years of Pop Art in England were quite heady times. Everything was bursting. There are those crushing 'sixties bores that go on talking about the 'sixties, but the beginning of the 1960s really *was* exciting, everything seemed to be blossoming. It did seem as though as soon as the Wilson government arrived, the white hot age of technology or whatever the phrase was, it seemed as if everything was possible. And I don't think that's just the age one was. You know that thing in Fitzgerald when he says it was great to be in one's twenties in the 'twenties, in the Jazz Age? Well, it was great to be in one's twenties in the 'sixties... Also, it did seem as if all those things like class, which have since reasserted themselves, were going. Obviously it wasn't the case, but it did seem so.'

For Buckley one of the most important factors in defining his ambitions as a painter in those early years as a student was his sense of belonging to a milieu of artists who were doing interesting things. His contemporaries at Newcastle included, in his own year, Tony Carter, with whom he became particularly close on the M.F.A. course at Reading, in which they both later enrolled; the painter Mark Lancaster, who, although one year ahead of him, stayed on in the department a further year to teach, and with whom Buckley shared a flat for four years; Bryan Ferry, two years behind him, who became his flatmate during his final year, replacing Lancaster, and who in 1972 was to find fame and fortune as the lead singer and songwriter of rock band Roxy Music; Tim Head, who began the course in 1965; Mali Morris, who was one year behind Buckley; and Rita Donagh, who had just completed her studies but who had been taken on as a student demonstrator and assistant to Hamilton.

Of the visiting tutors, the one who made the most impression on Buckley was Joe Tilson, who worked in the department for the whole of the autumn term in 1963 and who produced there, in full view of the students, some of his earliest Pop objects. 'He was making them there, so he ordered a lot of wood for the kids to use and lots of different materials, and started a workshop. Instead of having to go down to Sculpture to borrow a hammer, there was suddenly much more stuff available in the Painting School.' Although one suspects that the fact that Tilson was producing painted objects, constructed out of wood and then decorated, must have affected Buckley's assumptions about the conventions of painting, Buckley himself maintains that 'It was much more important that he was a very accessible and chatty person, that he wasn't aloof from students and that he was around at the time, and that he was there, working away, as well. You could watch him working, and he didn't mind. He had a record player in his studio. He livened the place up, rather; it was a fairly dour building.'

Among the other visiting lecturers who came for periods of one or two weeks were two more artists associated with Pop, the sculptor Eduardo Paolozzi and the painter Richard Smith.

Richard Smith. **Piano** 1963. Oil on canvas 178 × 280 × 112 cm. Trustees of the Tate Gallery.

Buckley recalls Smith's visit as having been in 1963, the same year in which he had been impressed by Smith's exhibition of shaped canvases at the Kasmin Gallery in London. Although Buckley saw little of Smith between 1963-1968, when the latter was living and working in the United States, he re-established contact with him when Smith returned to live in East Tytherton, Wiltshire, in the autumn of 1968 and worked with him as an assistant on an occasional basis for a period of about six months. Although there is no confusing the two artists' work — given the distinctions between their choice of materials, handling, sensibility and attitude towards their references — Smith's example was an encouragement to effect his own structural analysis of the conventions of painting, filtered through his own sensibility.[2]

Mark Lancaster, described by Buckley as 'an important catalyst of people and events, a connecting rod between a lot of worlds,' had made his first visit to New York in the summer of 1964 and had rapidly met 'everyone' in the art world there: among them

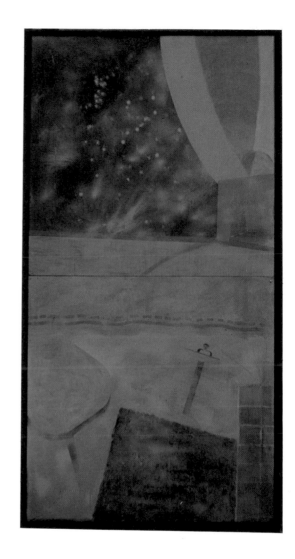

The upper section is a schematic rendering of the Majestic Ballroom, Newcastle-upon-Tyne, which offered popular lunchtime rock and roll sessions.

The lower section has elements of domestic interiors taken from colour supplements.

Its present condition is its present state of survival.

● **Middle Class Interior with Ballroom** *1963*
oil on hardboard 96 × 48 (244 × 122) The artist *cat. I*

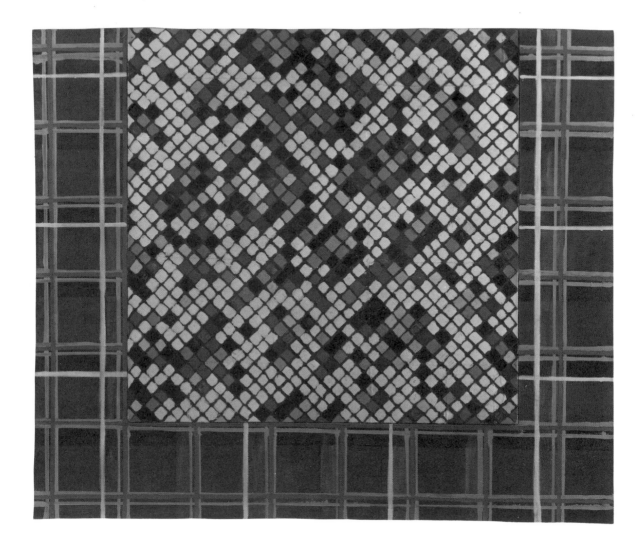

● **Toni's Restaurant** *1969*
oil on canvas 60 × 72 (152.5 × 183)
The artist *cat. 6*

The central tesselated area is a separate canvas
to the surrounding tartan.

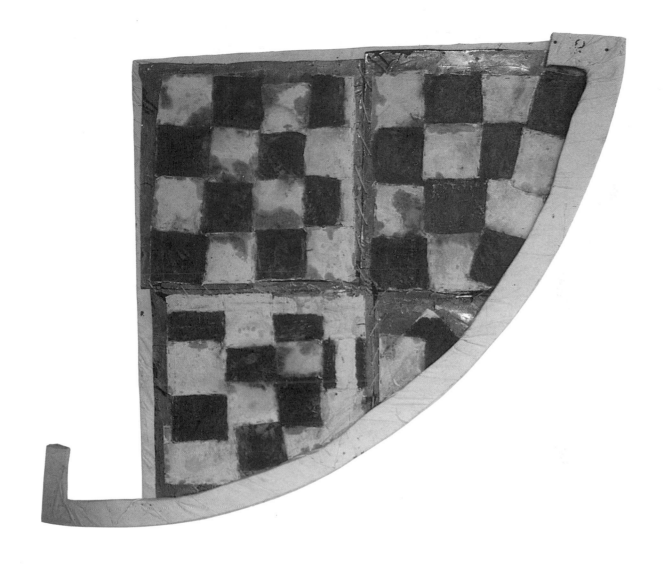

● **Agememnon** 1970
mixed media 60 × 79 (152.5 × 201)
David Hockney *cat. 9*

Whilst moving studios, a painting begun as a
quadrant had to be severed to pass through a
door. The parts were reassembled as seen.

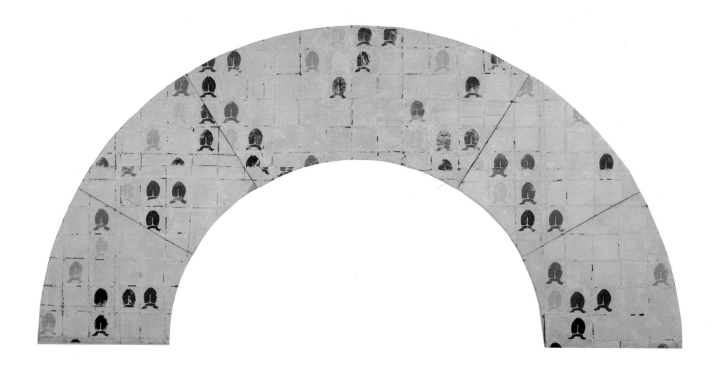

● **Tarantara** *1970*
encaustic on canvas on wood 55 × 108
(139.7 × 274.3) Max Gordon *cat. 7*

The five sections roughly represent stonework,
the coloured bishop's mitres (chess symbol) are
set in the grids according to the throw of a
dice.

● **Whitsun** *1970*
*acrylic resin, steel mesh, enamel 17 × 17 ×
3 (43 × 43 × 7.5)* Nigel Greenwood
Gallery *cat. 8*

A painted steel mesh, a segment abandoned
from an earlier painting is folded and fixed in
place with acrylic resin.

● **White Horse** *1971*
acrylic on canvas 60 × 128 (152 × 324)
private collection *cat. 14*

A white horse, referring to those cut into the turf of chalk hills but nonspecific, was painted onto a large canvas. The work seemed too large, so the canvas was pulled from the support, ripping where it had adhered to the wood. Restretched on a smaller frame, the repaired tears became the basis of the white areas.

The canvas was drawn upon, cut out, stitched together, painted and impregnated with resin. The whole was then cut into sections and bolted together.

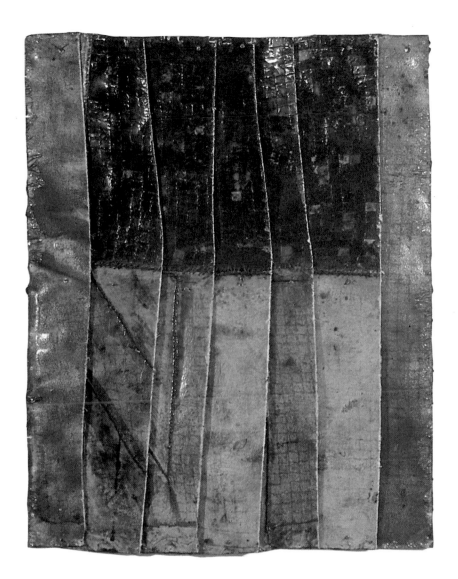

● **Hathaway** *1971*
acrylic resin impregnated canvas with glass fibre 50 × 39 (127 × 99)
Knoedler Kasmin Ltd. *cat. 16*

21

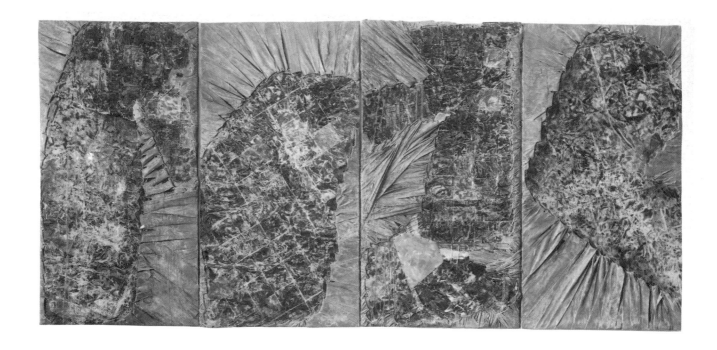

● **Rannoch** *1971*
wax on Scottish tweed in resin 87 × 188
(221 × 480)
Arts Council of Great Britain *cat. 11*

A project initiated by Richard Demarco, in which several artists were asked to produce work utilising the tweed of a Peebles manufacturer, resulted in a work which was later changed to the present form.

Sample squares of tweed cloth layered in resin with a glass fibre backing are fixed to wooden frames with a web of resin-dipped canvas and gauze. There is also a piece of wire brushed steel. The whole is covered with a layer of Japanese wax.

● **Fresh End** *1971*
*acrylic resin with rope on canvas 48 × 144
(122 × 266)* Max Gordon *cat. 13*

The format is based on **Rannoch**. Scar tissue
was in mind.

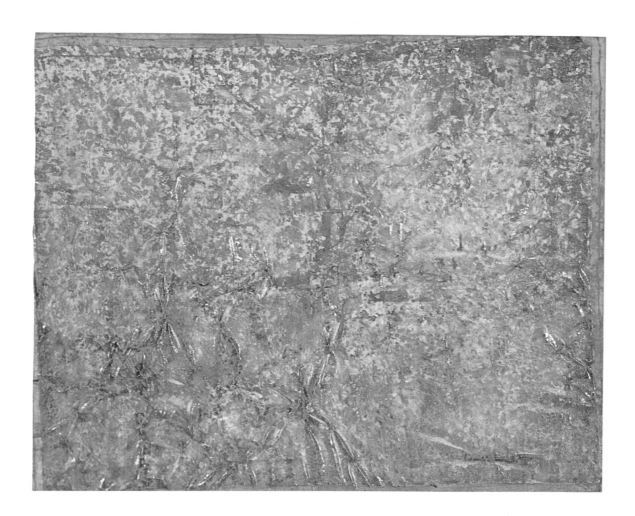

● **The View at Arles** 1972
*oil on canvas with stitching 48 × 60 (122 ×
152.5)* Stephanie James *cat.* 18

After producing from memory a satisfactory
rendering of the Van Gogh painting, the canvas
was removed from the stretcher, laid on the
floor and sanded off with a Black and Decker.
The roughness of the floor caused tears which
were then stitched together. After restretch-
ing, the canvas was varnished yellow.

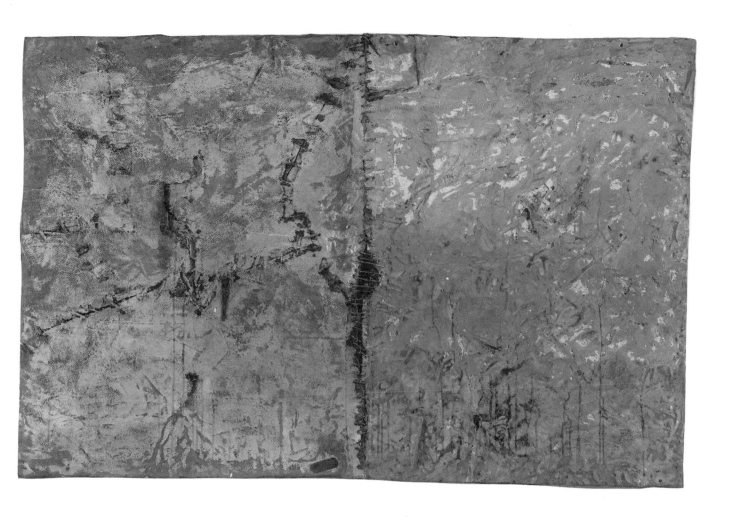

● **Ganges** *1971*
*wax and enamel over resin-dipped canvas
and fibreglass 38 × 56 (96.5 × 142)*
The artist *cat. 12*

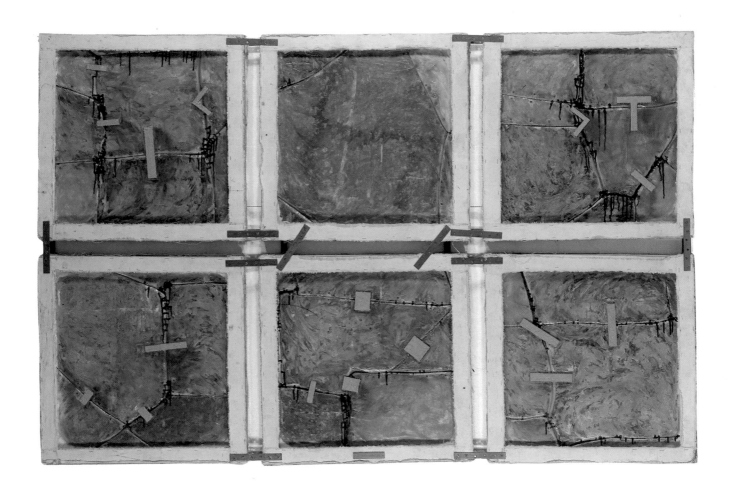

Many Angles *1972*
mixed media 50 × 77 (127 × 195.5)
Knoedler Kasmin Ltd. *cat.* 21

A continuation of the crazy paving theme. The brownish bloom below the surface is the result of the carpet tacks rusting as the water-based acrylic dries.

'Many Angles' is the name of a Kurt Schwitters assemblage in the Tate Gallery.

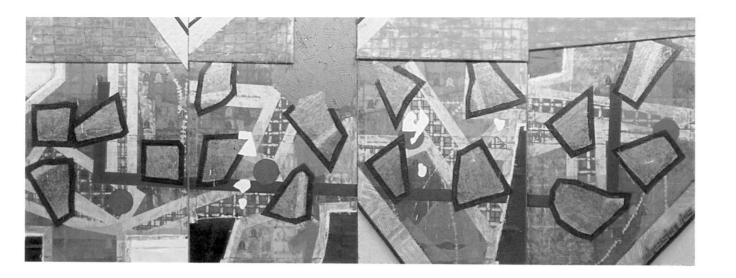

On moving to a new, clean studio in Cam-
bridge I felt I needed to make an anthology of
the themes that had engaged me over the
previous ten years. Both representations of and
actual fragments of previous works were used.
When the painting became itself, I stopped and
began a second version, titled **Chesterton,**
using elements that had not been included in
Chestnuts. I could have made further versions
(each one including the previous) but felt that
two indicated more than one and were suffi-
cient at that time.

● **Chestnuts** *1972*
*mixed media on four panels 72 × 192 (183
× 488)* Knoedler Kasmin Ltd. *cat. 22*

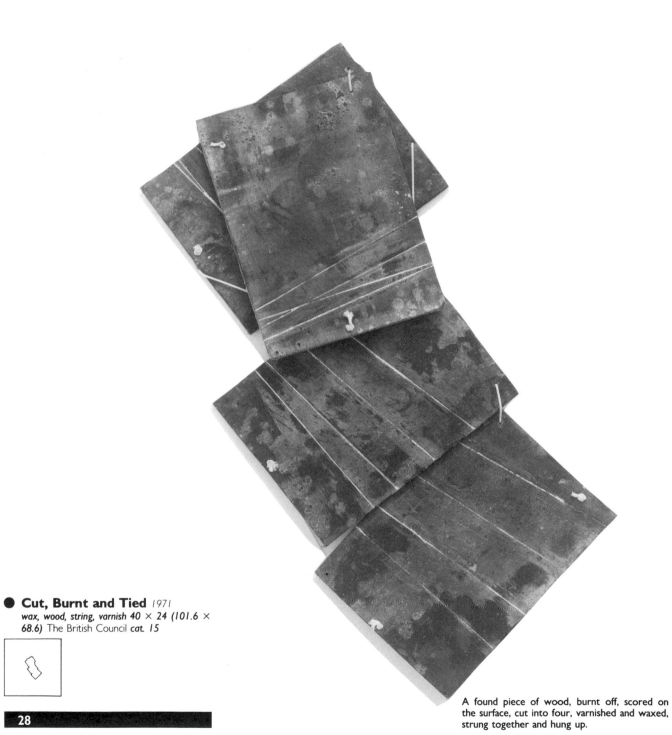

● **Cut, Burnt and Tied** *1971*
wax, wood, string, varnish 40 × 24 (101.6 ×
68.6) The British Council *cat. 15*

A found piece of wood, burnt off, scored on
the surface, cut into four, varnished and waxed,
strung together and hung up.

around and talking about it. Richard Hamilton was directly to people. Any of the visitors that came, if one didn't know about them one found out about them.'

Hamilton was directly responsible for three events which took place at the university while Buckley was a student and which were crucial for his later development: the transfer of the Kurt Schwitters **Merz** wall from Ambleside in the Lake District to its permanent home at the university's Hatton Art Gallery; the reconstruction of Marcel Duchamp's **The Bride Stripped Bare by her Bachelors, Even,** generally known as the **Large Glass,** for the Duchamp retrospective held at the Tate Gallery in 1966; and an exhibiton, also at the Hatton Art Gallery, of the work of Francis Picabia, including paintings made immediately before the First World War through to about 1930.[5]

Buckley helped hang the Picabia show, which took place at the Hatton in 1964, and recalls that he learned a lot about the work simply by handling it and scrutinising it at close quarters. On the occasion of his first exhibiton at the Kasmin Gallery in 1972 he presented Picabia as an exemplar, commenting in an interview on his admiration of Picabia's 'mobility of style': 'It seems to me that in an age when serialisation in painting seems to make so many painters falter and hold back — not give their all in any particular picture — Picabia's maxim that one should change one's ideas as often as one changes one's shirts gives one the opportunity to start afresh, and do one's best in it.'[6] Important though Picabia was to Buckley in clarifying his own position as a young artist, one should guard against giving too much importance to a single off-the-cuff remark. 'I just said that Picabia thing on one occasion to explain to somebody why the paintings didn't all look the same, and it's just been a quotable quote. It seemed an apposite way of describing my attitude at that moment.'

Buckley was not directly involved in the removal of the Schwitters **Merz** wall from Ambleside, but he did visit it at its original site and also witnessed its installation at the Hatton. Hamilton's enthusiasm for the project fired him, too, particularly as he was already familiar with Schwitters: he had seen an exhibition held at Marlborough Fine Art, London, in 1963, and knew the single collage owned at that time by the Tate Gallery.[7] 'I like the idea of Schwitters's work much more than I like it in general,' Buckley explains today. 'There *are* some exquisite things, and I like them in isolation, but if you see lots of them, it begins to pall.' He agrees that it is the constructions, rather than the collages, which interest him, and adds that he remains especially fascinated by the Hanover **Merzbau** because of its enigmatic quality. The sense of almost organic growth of the latter bears particular comparison with Buckley's methods, especially in his early work, which likewise emphasizes the progressive stages by which the objects were constructed in preference to their compositions or formal solutions as static entities. 'One is occupying one's time with no end in sight, necessarily,' Buckley assents, 'rather than working towards a fixed point.'

Hamilton worked on the **Large Glass** reconstruction with a group of students for a period of about six months leading up to its exhibition in 1966. Buckley played a minor role in the process, cleaning some of the glass, and he seems to have felt a personal involvement, too, through having met Duchamp briefly on one occasion that he had passed through London. The Duchamp connection went much deeper than this one project, however, since Hamilton had known him well for some time, had produced 'a typographic version' of Duchamp's **Green Box,** and spoke of him often and with great enthusiasm.[8] Duchamp has consistently stood out for Buckley as one of the great twentieth century artists, and it is from him as much as from Johns — himself influenced by Duchamp — that Buckley developed his own propositions for the change of function of an object.

Braced by this contact with the art of Duchamp, Picabia and Schwitters, and aided and abetted by Ronald Hunt, a librarian at the university and an aficionado of Dada, Buckley chose the first two years of Dada at Zürich and in Paris as the subject of his final-year dissertation. By this time, however, he had come to appreciate the connections between this historical period and the Pop Art of his own time. Pop Art for him was represented by artists whom he knew personally — Hamilton, Smith, Tilson, Hockney (whose shaped canvas of 1961, **Tea Painting in an Illusionistic Style,** he remembers having seen as a student in a group exhibition) — and by other painters, such as Johns and Rauschenberg, whose work he had seen in exhibitions. By and large, however, it was the work not of any particular artist but the spirit of the movement as a whole which stimulated him, apart, perhaps, from the example of Johns, with whose work his was to engage in a lively and complex dialogue.[9]

'I think I was affected a great deal by Pop Art, you can't really over-emphasize how much at the beginning: just the attitude of what could be source material, which I didn't know about until that happened. Then I realised, of course, that it was the same attitude as other artists throughout the century, such as Schwitters, Cornell and Picasso. Also the subject matter that was actually painted by many twentieth century artists which was non-bourgeois. You could even go back and make a case that the Impressionists were the people who started it, because they didn't paint what was currently acceptable as tasteful, but then, of course, they soon made taste. And Pop was accessible to the public in the same way as Impressionism was.'

Buckley recognises that in the paintings he made as a young student — exemplified by **Middle Class Interior with Ballroom,** painted in autumn 1963 in the first term of his second year at Newcastle, and by the **Interior** with plaster ducks which followed soon after — his concern with 'taste and style and how environments reflected taste and style' was rooted in the Pop aesthetic and in themes which Hamilton, in particular, had dealt with. Rather than make overt depictions of such subjects, however, he sought ways of synthesizing his interest in such matters with his predilections for earlier twentieth century painting so that the dialogue with taste and environment would

 Mandolin *1973*
oil on canvas on wood and PVA on canvas 36
× 48 (91.5 × 122)
Michael Abrams *cat. 23*

Painted at the time of Picasso's death.

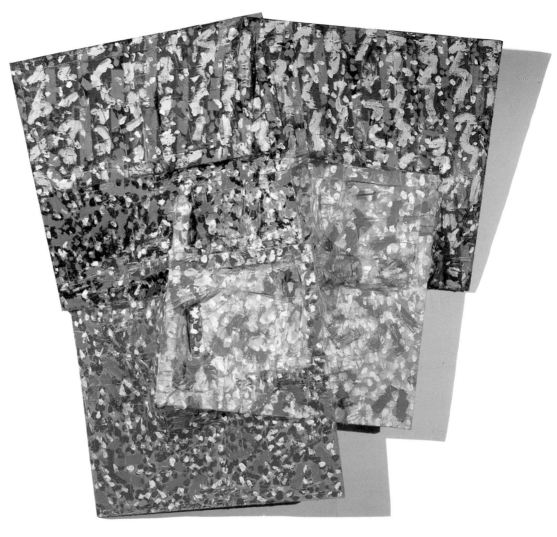

● **Head of a Young Girl**
no. 1 *1974*
*acrylic on cheesecloth and cotton duck 71 ×
65 × 11 (180.5 × 165 × 28)*
Merseyside County Council: Walker Art
Gallery Liverpool *cat.* 26

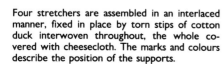

31

Four stretchers are assembled in an interlaced
manner, fixed in place by torn stips of cotton
duck interwoven throughout, the whole co-
vered with cheesecloth. The marks and colours
describe the position of the supports.

● **Triptych** 1972
oil on canvas 24 × 54 (61 × 137)
courtesy of Brooke Alexander, Inc. *cat.* 17

The stretcher frames are woven with torn canvas strips which also form the hinges.

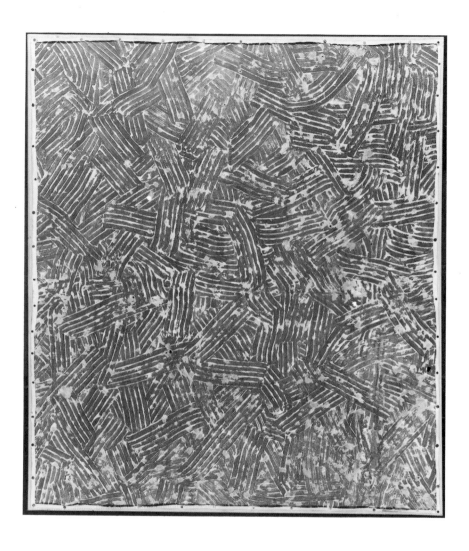

White PVA paint combed whilst wet. After drying, various colours were sprayed to mix on the canvas to create the earth colour. Finally the surface was sanded, the canvas turned and tacked at the edges to show the support. 'Trullisatio' is an Italian technical word for the process by which the first layer of crude plaster laid onto a wall is scored in order to provide a key for later smoother finishes.

● **Trullisatio** 1972
PVA on canvas 43 × 39 (111.5 × 99.5)
The Trustees of the Tate Gallery
cat. 19

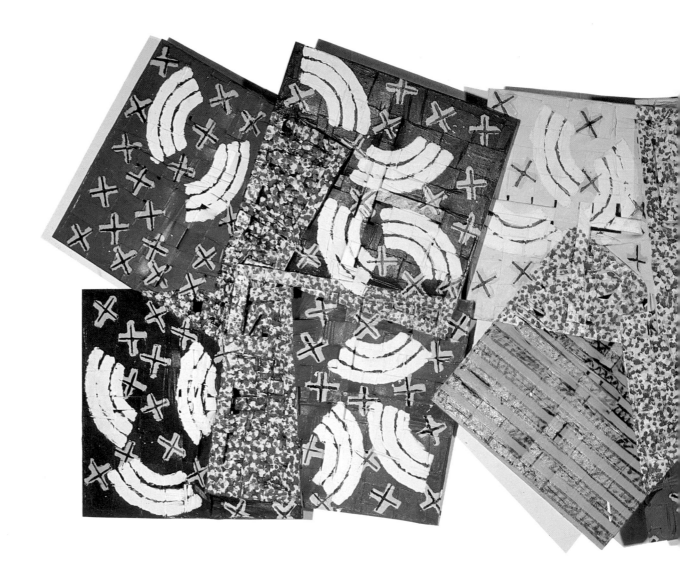

● **La Manche** *1974*
acrylic on canvas 72 × 212 × 8 (183 ×
538 × 20)
Saatchi and Saatchi Company *cat. 27*

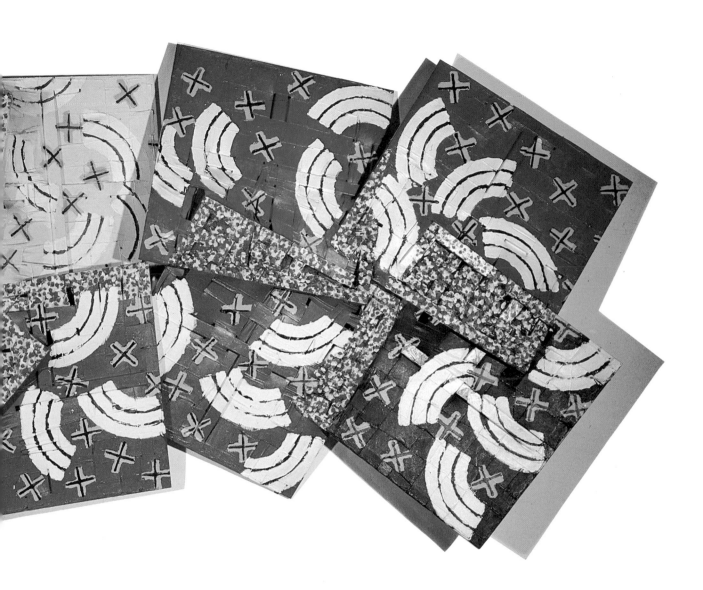

Fabricated in the same manner as no. 26 but without the cheesecloth.

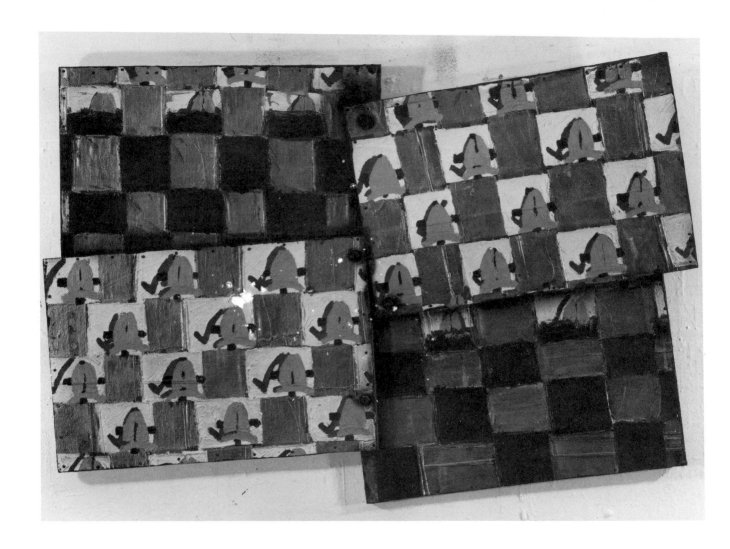

● **Harlequin** *1972-80*
oil and enamel on canvas on board 36 × 48
(91 × 122) The artist *cat. 20*

A large painting on canvas with a padded frame
was cut down and altered to this form.

Interior 1964. Mixed media with plaster ducks 60 × 60 (152.5 × 152.5). Present whereabouts unknown.

take place within the very fabric of the paint and its support.

'The **Middle Class Interior** was something like the background one came from, and yet I'd now discovered working-class ballrooms, which is something I hadn't had any commerce with before. So it was a painting about two things I knew about, but adjacent: a sort of stream-of-consciousness.' In seeking to marry two disparate realities, Buckley thinks that he had in mind the split-screen techniques with which film-makers were then experimenting.[10] It was his own experiences, however, which he was presenting in his painting, with the middle class interior standing for his past and the ballroom as a token of his new life.

In view of the fact that **Middle Class Interior with Ballroom** was Buckley's first large painting, it is remarkable that it prefigures so many themes of his mature work. The allusions to different kinds of experience which are dealt with here in a fairly transparent manner continue to feature, but in a far more abstracted form, in the mature paintings, which Buckley describes as 'collisions' of a number of allusions. The urge to incorporate layers of time within a static object was to emerge, later in the 1960s, in the artist's habit of deliberately leaving visible traces of the procedures taken in making each painting. An evident delight in challenging received notions of taste exists here, too, if only in embryonic form. In retrospect Buckley thinks that one of the missions of his work has been to *redefine* taste. By the late 1960s his professed ambition was to make paintings that were as ugly as possible, 'difficult and non-seductive.' He is certain now that he failed to do so in many cases, perhaps because his pleasure in the materials and processes was stronger than the urge to desecrate. He agrees, moreover, that the pictures have become increasingly seductive over the years. 'I suppose my views have changed: like I've *done* that bit, and I'm somewhere else now.'

The relationship between formal self-sufficiency and representation, which is at the crux of all Buckley's work, is particularly evident in **Middle Class Interior** and in **Interior**, which incorporates actual objects such as plaster ducks, net curtains and a frame made of synthetic material purchased in Wool-

worth's. It is only in the overtness of their references that these are distinguished from the characteristic later paintings reproduced in this book, for a figurative content is implicit in all but a few rare cases. The specificity of the devices presented, and the allusions to the work of other artists as well as to places, actions and events, disclose the origins of the paintings as distillations of experiences or things seen. Buckley's paintings are not abstract in the sense that other painters have understood the term: that is to say, as a series of marks and forms related purely by their own internal logic. It is as though even the most basic forms employed by Buckley are offered within inverted commas, so that they are not true abstractions but pictures *of* abstractions, and in that sense not abstract at all. It is thus appropriate that Buckley's mentors should be, on the one hand, artists such as Duchamp and Picabia, Johns and Hamilton, whose concern was with the expression of ideas by means of objects — whether found, 'assisted' or painted — and, on the other, artists as diverse as the Cubist-period Picasso, Schwitters and late Mondrian, each of whom in his own way used a language of apparent abstraction to represent visual sensations and specific aspects of his immediate environment.

Buckley appears to have felt uneasy about the conspicuousness of the figurative content of his early interiors, and in the three years that followed he sought ways of stripping down such references to a form so simplified as barely to be recognisable. Illusions of interior spaces were hinted at in a very oblique fashion by means of generalised architectural forms that might be read as doors or as the join between a wall and a floor. 'Most of them were of a sort of five by four foot format. They were simplified architectural experiences, but they were taped and done with acrylic paint or emulsion paint. They were just vacuous.' Buckley thinks that the departure of Hamilton from Newcastle in 1966, and the extra year that he himself spent at the university on a Hatton Scholarship, may together have conspired to rob him momentarily of his confidence and to turn him inwards. The acrylic taped abstractions which Mark Lancaster and other painters associated with the Rowan Gallery were producing seemed to offer a solution, though Buckley soon realised that it was not one suited to his own way of working. 'I think I started off very clearly knowing what I was doing in terms of **Middle Class Interior**, but then I lost touch with what I was trying to do and produced a lot of paintings which were very influenced by the invention of masking tape, which changed one's life for a time. And, in fact, they're the only real batch of work I've destroyed.'

Untitled (1967) is one of the few paintings in the Minimal mode which he found sufficiently satisfactory to keep. The experience of those three years of pictorial austerity, however, seems to have been a salutary one in sharpening his awareness of his own intentions. 'I know I could make a Minimalist painting or a particular kind of painting, but being able to do that, I want to do something else as well, at the same time, to pack as much in as possible. A long time ago Tony Caro said he didn't like my

work, he found he couldn't like my work because it didn't seem clear enough to him. My reply was, "That's the whole point." That's the fun of it all. There's something to see, something to find.'

It was on his arrival at Reading in the autumn of 1967, when he began a two-year Master in Fine Arts course, that Buckley began to realise that the most fruitful path for him to take was a middle course between the two extremes — of overt figuration and of unrelenting abstraction — with which he had experimented at Newcastle. Buckley, though, was after something more intransigent than the wishy-washy ambiguity that characterised much abstract painting in Britain in the 1940s and 1950s. The dual readings which occur in Buckley's work are equally clear and specific. **Toni's Restaurant** (1969), for example, has a rigorously geometric abstract pattern which bears comparison with the work of the de Stijl group, but it alludes also to tablecloths in cheap restaurant interiors.

'I don't think I deliberately excluded the possibility ever in my life of using representational images. I just haven't found the moment to do it in the way I've gone so far. So that's just the way it happens to be.' Buckley agrees that he has perhaps been worried, as have other twentieth century painters, that depiction in a traditional sense would somehow threaten the sovereignty of the paintings, making them illustrations of things external to them and thus stripping them of some of their physical presence as things in themselves. 'There's some sense in that, because I feel that it would dilute what I'm doing. It's a question of keeping the two forces of self-sufficiency and representation in balance. If it falls heavily on either side, then I lose what I've found.'

Although **Untitled** (1967) was produced during Buckley's first term at Reading, it was only in the following year, with **Dos**, that he felt that the issues which he had confronted in the previous five years began to gel into a personal idiom. 'I knew where I was going. Suddenly it was clear.' He thinks that the discussions he had about art and its possibilities with Tony Carter, who had preceded him to Reading from Newcastle a year earlier, were of particular importance to this process. 'We became very intimate because we were living and working in adjacent rooms. We weren't supposed to be living in the rooms, but we had little beds tucked away behind the paintings. It just became a real situation rather than a rehearsal, and things became urgent, I suppose.'

Like one or two other early paintings, **Dos** has its origins in a literary source, specifically in the first part of **U.S.A.**, the trilogy by the American novelist John Dos Passos. Much of this novel dealt with the First World War, for which Buckley says he had a vicarious feeling. References to the conflict and to wounds can be read into the actual bandaging of the frame which served in place of a conventional artist's stretcher, which in its transformed use itself suggests a punning reference to a makeshift support for a wounded person; the sawn-off wooden stumps of the frame, painted red, can be read as bloodied injuries, and the effect of the enamelled tin in the centre as an allusion to the mud of Flanders.

Dos is a powerfully emotive painting, and it is easy to get carried away and to interpret it as a battle cry, a violent assault on the conventions of painting. Acutely aware though Buckley was of the elements which traditionally defined a painting — paint applied to a canvas stretched over a rectangular support — it was not out of defiance of these conventions or of the aesthetic of American critic Clement Greenberg, which then held sway, that he decided to use such unusual methods. It was a question, rather, of making do with the materials that he had to hand, particularly as he had little money at the time with which to buy good quality artists' paints and canvas, and of devising ways of working that seemed natural and satisfying.

'The Greenberg aesthetic didn't touch me, because I wasn't in any of the places where it was going on. I was neither taught by people who were concerned with that nor people that made it. At Newcastle I never had the sort of conversation with people about things like "the edge", "the integrity of the picture plane", etc. I wasn't worried about it or about how things changed, because I never thought about painting in that sort of way.'

Buckley's reliance on intuition and on pragmatic decisions accounts for the fact that even in working as an occasional assistant for Richard Smith in 1968, helping him to stretch shaped canvases that were almost sculptural in form, he was affected more by the older artist's attitudes than by the intellectual justification which critics were advancing for this kind of work.[11] 'I think it was a general rather than a specific thing. It was again, especially with Dick — who had all this information, magazines, contacts — that one talked about matters in general. It was sort of in the air.'

A clear indication that for Buckley painting has consistently been a process of discovery, rather than a theoretical plan of action, can be gleaned from the fact that the titles of the pictures he began making in 1968, such as **Höch** and the first of the **Crazy Paving** pieces, occurred to him only after the paintings were finished. In the case of the former, a technique of stapling patches of canvas onto a wooden support, which he had improvised for the occasion, reminded him of a work which he had seen by the Dadaist Hannah Höch. The **Crazy Paving** pictures, for their part, though related to the continued use of specific architectural motifs in other small paintings such as **Pergola** (1968), were not planned as a series. They had their origins, rather, in a single painting in which the interlocking shapes triggered the connection with a technique, associated particularly with the footpaths and patios of humdrum suburban housing, by which a surface is covered with random fragments of paving stones cemented together. It was the appeal of the devices, and of the scope offered by a subject that was abstract in appearance but concrete in its reference, that led Buckley to make others in a similar vein. One painting engendered another, rather than all of them resulting from a proposal to produce a series of works on a given theme. 'The idea of that serialisation thing, of setting up a programme and working on it, didn't seem very much fun. I think one should be able to enjoy what one is

● Scarlet *1973*
PVA on canvas with powder pigment and
fabric tape 32 × 70 (81 × 178)
Scarlet Buckley *cat. 25*

Painted after the birth of Scarlet Buckley, name
plate in plexiglass lower right.

● **Japonaiserie** *1973*
oil and PVA on padded canvas on three boards roped together 66 × 36 (107.5 × 91.5) Knoedler Kasmin Ltd. *cat.* 24

A stuffed van Gogh!

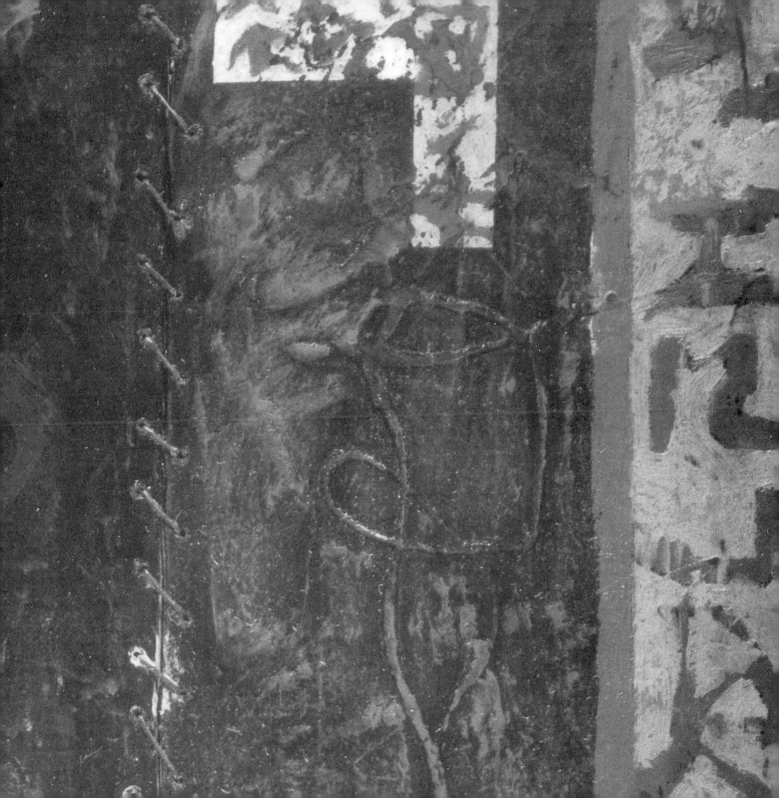

doing.'

Many of the paintings that Buckley produced in the late 1960s and early 1970s were made either from elements of early works which he had discarded or from junk found in skips. This was largely a practical consideration, as he had the energy and ideas to produce pictures at a fast rate but not the financial resources to buy conventional artists' materials. He was motivated also by a sense of thrift, inherited, he thinks, from his mother. 'I think there's plenty of stuff in the world already,' he explains, 'and if you're going to add to it, you should make it worthwhile.' He is averse to the notion of waste, and this applies as much to his time as to the materials he uses. Rather than discard an unsuccessful painting, he would use it as a starting-point for making something else. 'It waits and something happens to it eventually. Sometimes it turns out, mysteriously, that something which didn't seem right looks okay when you look at it again, whereas something else doesn't. There have been cases where I've altered or stripped down a painting later on, because I felt it was awkward the way it was.'

No matter how logical the initial structure of his paintings, Buckley has always been prepared to break that logic with an impulsive decision if he is dissatisfied with the way the picture looks, and to welcome accidents as well as changes of mind as an integral part of the process. 'One sets off in a rational way, certainly with all the very structured paintings. They frequently are quite well-plotted at the beginning. I don't know what it's going to look like, in a sense, but I know what the basis of the thing is. I decide on a set of materials I'm going to buy. I'll go to the lumber yard and order two hundred running feet of $1 \times 1''$ and two hundred of $2 \times 1''$, a certain number of boards and things, and I'll find some tubes or something and start off in the studio making these. So the foundations of the work can be quite spontaneous in how it's put together. But then, of course, having decided, there's a period of time — pregnancy, if you like — when having seen and laid the materials together, seen how they can be fabricated, I've actually got to fix them together. And that takes time, because there's the gluing and waiting for the last piece to dry, and so on.

'During the process it's beginning to emerge what I'm going to do on top of that, what painting is going to be on top of the form. But of course the form is already pretty fixed. Now I have the confidence to do that. At one time I *didn't* have the confidence to know that I could do that, which accounts for some of the paintings earlier which were cut up and reassembled, because I'd made them in that sort of way but I couldn't pull it off with the painting on the top, or maybe I didn't know enough to do it first go. So they had to be rescued by being cut up and physically altering them.'

A refusal to be precious about his own work, a willingness to plunder the objects he has made if they can serve more usefully as elements for another painting, lies behind the pragmatic solutions which he devised for paintings such as **Agememnon** (1970), **Harlequin** (1972), which eight years later was dismem-

bered and reassembled in a different form, and **Triptych** (1974), a two-panel painting onto which has been fixed the fragments of the original third panel acknowledged in the title.[12] **Head of a Young Girl no. 7**, completed in 1976, started life three years earlier as a flat painting in five colourfully-painted vertical sections which abutted each other; Buckley disliked it in that state when he saw it hanging in an exhibition and later took the panels apart, covered them in grey enamel paint so that the colour showed through only around the ridges, and reassembled them in their present form, which on his own admission owes something to a device common in advertising images for representing things spilling out.[13]

The glimpses which we are allowed of the actions taken by the artist — vital evidence of the decision-making process — encourage us to apprehend the paintings not as formal exercises but in terms of human behaviour.[14] Although Buckley today agrees that his art can usefully be analysed in such terms, it is a judgment which even *he* can make only retrospectively, since he arrived at his way of working not with the aid of theory but by means of intuition, practicality and trial and error. In 1969, short as ever of materials, he was given a 5×4 foot stretcher and a certain amount of canvas in a 3 foot width. Rather than despair at the fact that the two elements did not match in size, he found a way of making use of them both together, ripping the canvas into strips of equal width and weaving them together to make a painting of a trelliswork fence, which he titled **Beech**, after the wood out of which the real thing might be made.

After **Beech** Buckley seemed prepared to take anything — a graphic or geometric device, a chance reference, a real or imagined place, an ordinary object or even the work of another artist — as a point of departure. Often the challenge seemed to be to juggle as many different elements as possible without allowing any of them to dominate one's experience of the painting as a physical fact in its own right. **Toni's Restaurant** (1969), the title of which was taken from a book which he is no longer able to identify, has personal associations with the 'scruffy cafes' which he used to frequent in those days, as do the tartan and diamond patterns, which are reminders of the garish tablecloths which adorned such interiors. Grids were a common device in the work of other artists of this time, useful as a rigorous means of structuring a painting. Buckley's superimposed grids, while taking this function into account, double as depictions of cloth; this provides a subtle lesson in itself since, as Buckley points out, one of the reasons that grid patterns are so universal is that they have developed in many instances from the way in which fabric is woven together.

Architecture, music, literature, geography, personal friendships, games and traditional attributes of painting are among the many areas of experience alluded to in Buckley's paintings of the early 1970s. It matters little that not all the references are going to be spotted by every viewer, that some of them are essentially private and that many of the titles are false pointers, for what comes across in this animated free-for-all

Head of a Young Girl no. 7

1973-76
*enamel over acrylic on canvas 82 × 67
(208.2 × 170.1)*
Aberdeen Art Gallery and Museums *cat.* 30

is Buckley's readiness to make his paintings meet the rest of the world halfway. **Tarantara** (1970), with its extended chess game and complicity with chance, could on one level be interpreted as a jovial memorial to Duchamp, who had died in 1968 and who had spent at least as much of his time in later life playing chess as making art; as a decorative object, however, pieced together in the fashion of the keystone work of a traditional arch, it needs no justification. The musical subject of **Jazz** (1971) refers simultaneously to the treble clefs printed on the cloth from which part of it is made; to the incorporation of musical instruments in the late Cubist paintings of artists such as Juan Gris, the structure of which Buckley had in mind; and to the carefree but self-confident sense of improvisation which the artist enjoyed in such music and which he sought to adapt to his own ends. **Jazz** seemed an inevitable and cheerfully time-worn title for a painting which was so evidently *not* old-fashioned.

The many geographical references in Buckley's paintings of the early 1970s should be interpreted with great caution. He is by no means a landscape painter in wolf's clothing, and the titles are often arbitrary, partly out of convenience and partly as another good-natured way of taunting the literal-minded. **Rannoch** (1971), for instance, takes its name from a moor in Scotland simply because it is made out of Scottish tweed. **Ganges** (1971) has nothing to do with the Indian river, but it does connect with a painting done in the previous year, **Solent**, following on from the aquatic titles of other paintings such as **Gone Fishing** (1970) — so named because he left it in an apparently unfinished state — and the closely-related **One More River** (1970). The titles provide a useful means of identification but do not necessarily explain the references involved in a particular work; as often as not, the clue is to its origins in another painting with a similar title, as was the case, for instance, in the **Crazy Paving** pictures.

Fresh End (1971) was painted immediately after **Rannoch**, which it takes as its model both for its basic structure in four panels and for the plotting of its collaged elements, though it is only about half the size. As with later pairs of paintings — **Chestnuts** and **Chesterton**, both painted in 1972, being the most notable examples — the second work is a reaction or alternative to the first. With its subtly modulated surface, pale and translucent, **Fresh End** is one of the most reserved and confidential in tone of all Buckley's works. Its starting point was the artist's friendship with a girl who had many operational scars.

Buckley refers to his work of the early 1970s as his 'brutalist' period, characterised in paintings such as **Ganges** (1971) by an uningratiating rawness of surface, crudeness of material and violent techniques such as slashing, stitching and tying of the canvas. As the title of **Cut, Burnt and Tied** (1971) attests, Buckley was prepared to avail himself of any method, no matter how unprecedented, if he thought it would lead to a new discovery or an interesting effect. Although the shaped canvas was of general currency at the time, Buckley was averse to making the elements of paintings such as this conform to a preconceived outline, preferring them to find their own position by hanging them on nails.[15] Over the years Buckley's assault on the conventions of painting has given way to a calmer appraisal of their limitations; processes which in the early paintings are left as exposed as possible gradually began to be taken for granted, so that there is no need to continue labouring the point. Compare, for instance, the emphasis on structure and on the relationship between front and back in the **Triptychs** of 1972 and 1974 with the almost nonchalant incorporation of a decoratively-painted hinged panel in **With Pipes and Drums** (1981). A similar change has occurred in Buckley's use of materials: 'The paintings became less crude whilst I was in Cambridge from 1972 to 1974, because I could afford to use things that I couldn't use before. Later on I've used things that I've preferred to use — I still use eccentric things from time to time. I don't think the innovation has gone on,' he concludes, 'because I have a sufficient repertoire for what I'm doing at present not to have to expand it for the moment.'

The evolution in Buckley's work attests to a decision which he made early on to create for himself an area of enquiry that was sufficiently flexible and open-ended to sustain him indefinitely. 'Certainly,' he acknowledges, 'I was very conscious of looking for a way of working which didn't exclude anything.' He has continued to devise new ways to examine the standard elements of painting: different types of paint, mark, format and support; the varying relation of canvas to stretcher and of the picture surface to the wall; the emotive properties of colour or pattern; the interdependence of structure and decoration; and the fusion of subject into form by means of succinct allusions and more descriptive images alike.

One More River 1970. Mixed media on wood 65 × 69 (165 × 175). Edward Albee, New York.

● Three Figures Dancing 1976
*wax encaustic on cotton duck with scenic
gauze 88½ × 75½ × 8 (225 × 191.5 ×
20)* Arts Council of Great Britain *cat. 31*

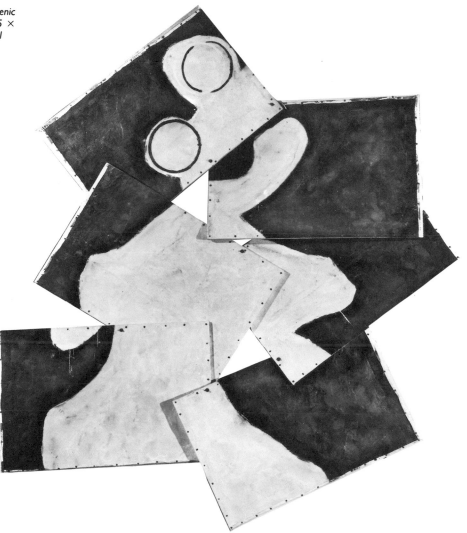

Three figures drawn on six adjacent panels and
then 'exploded'. Made at the request of Kitaj
for his Arts Council exhibition, **The Human
Clay.**

Buckley was left pretty much to his own devices in the two years of his postgraduate course at Reading, where he finished in the summer of 1969. It had seemed a natural place to go: it was a university department, which meant that its structure was similar to the course at Newcastle, and its post-graduate fine art course, instituted in 1966, was the first at a British university. Tony Carter had arrived a year before Buckley, in the first intake of M.F.A. students, and another friend from Newcastle, Rita Donagh, had been teaching on the B.A. course at Reading since the autumn of 1964. Buckley enjoyed the proximity of London and its exhibitons, particularly as he was able to stay in Mark Lancaster's Bath Street studio (previously occupied by Richard Smith), both before and after Lancaster's appointment in 1968 as the first artist-in-residence at King's College, Cambridge.

In 1969, together with the sculptor Michael Craig-Martin, to whom he had been introduced by Mark Lancaster, Buckley made his first visit to the United States, thinking that it was time that he experienced the New York art world for himself. He stayed with Henry Geldzahler for the month that he was there and, through Lancaster, met Jasper Johns. On his return to England in the autumn of 1969 he accepted two part-time teaching posts, first at Canterbury College of Art — where, with Craig-Martin as a close colleague, he dealt mainly with first year painting students one day per week — and for the spring and summer terms at Leeds College of Art. At Leeds he taught two days per week, sometimes staying with Keith Milow, who in 1969 took part with him in the **6 at the Hayward** exhibition and who, like Buckley, showed in the following year at the Nigel Greenwood Gallery in Glebe Place.[16] In 1971 he began teaching as a visiting lecturer at Chelsea School of Art, a commitment which continues to involve him for between three and ten days a year. Though he enjoys tutoring on an occasional basis, Buckley found a regular teaching routine both exhausting and irritating, and it was thus with considerable pleasure and relief that he accepted the post of artist-in-residence at King's College, Cambridge, in the autumn of 1972. In the same year he joined the Kasmin Gallery in London. Soon afterwards he married Stephanie James, who gave birth to their first child, Scarlet, in Cambridge in 1973; their son, Felix, was born five years later.

'I had been uncomfortable and continually tired, not having enough to eat, having to travel distances and constantly changing places to live, and not having found the right dealer yet. As soon as I found Kas — I had arranged to join Kas before the Cambridge thing was finalised — suddenly everything was calmer all round. After the strain of London, it got a lot better.' He agrees that the paintings which he produced in Cambridge had a more thoughtful air than the works which had preceded them. 'They were more reflective and more elaborate. Before that, life had been hard work. There was a constant financial strain.'

Slightly daunted at first by the sudden improvement of his circumstances, Buckley decided to reassess the work he had produced during the previous decade and to incorporate within one large painting fragments of, or allusions to, many of his old favourites. He called it **Chestnuts**, a title which he appended — with a mixture of pride and self-mocking humour — to the surface of the canvas itself. The whole is like an enormous stretch of crazy paving or patchwork into which the artist has inserted not only characteristic types of construction (canvas collaged, tacked and interwoven in bandaged strips) but also grids and other favoured types of pattern and imagery, depictions of details of particular works such as **Tarantara**, and actual pieces of abandoned paintings. Such recycled fragments feature as the large patches which cover the surface, as the small irregular white areas (from **White Horse**, 1971) and as the elements in relief, which are sections of some of the artist's early finger paintings. The large scale four-panel format is itself adapted from two paintings of the previous year, **Rannoch** and **Fresh End**. Quotation piled on quotation, allusion on allusion, **Chestnuts** is a celebration of the personal vocabulary which Buckley had been developing from his earliest student days.

On finishing **Chestnuts**, Buckley was conscious of the fact that he had not found the means to include in that painting other important elements of his earlier work, particularly of the brutalist pictures of the early 1970s. He therefore made another

Chesterton 1973. Mixed media on four panels 72 × 192 (183 × 488). Private collection, Sweden.

recapitulatory painting in the same format and dimensions, naming it **Chesterton** after a street and district of Cambridge, the title echoing that of the previous work as a gentle way of drawing attention to the similarities of structure and intention between the two pictures.

During the Cambridge period and into the mid-1970s Buckley produced a number of paintings which, rather than alluding to his own history, made specific reference to the work of other artists or to movements in twentieth century art. Although he had occasionally employed such tactics in earlier pictures — **Höch** being the most obvious example — the emphasis now was much more clearly analytical. Cubism, for instance, is a recurring theme from **Harlequin**, begun in 1972, through **Mandolin** (1973) — named on the day that Picasso's death was announced as 'a little two-minute silence', an act of homage in its technique, imagery, colour and title — to the seven-part **Head of a Young Girl** series instigated in 1974. The first of these paintings, which prompted the artist to make other

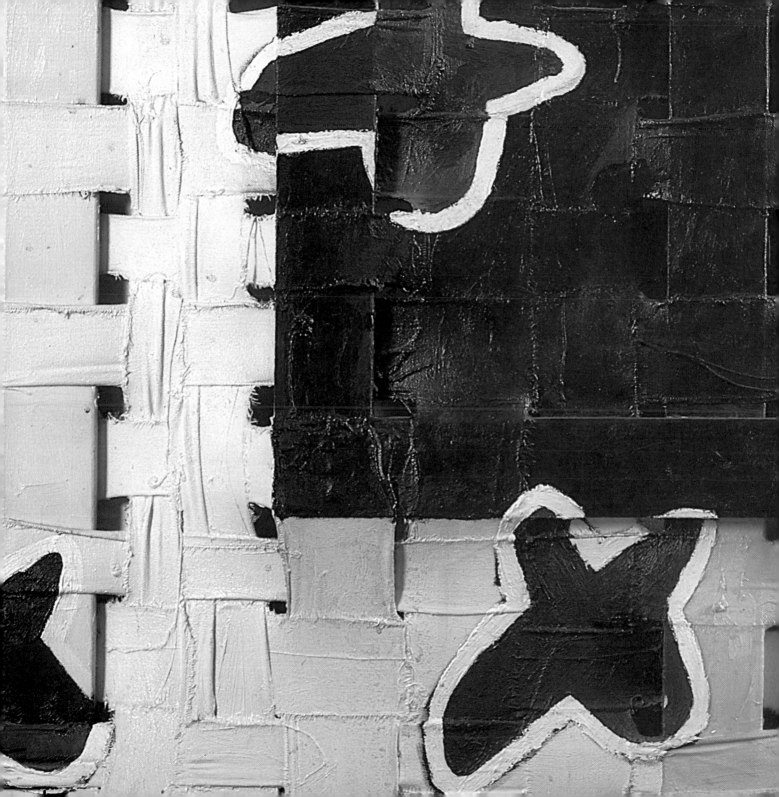

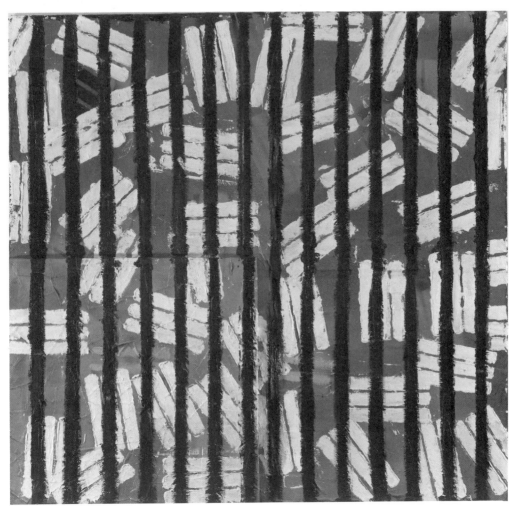

● **Splash no. 2** *1975-77*
oil on canvas on board on canvas 48 × 48 ×
4 (122 × 122) J. Kasmin *cat. 32*

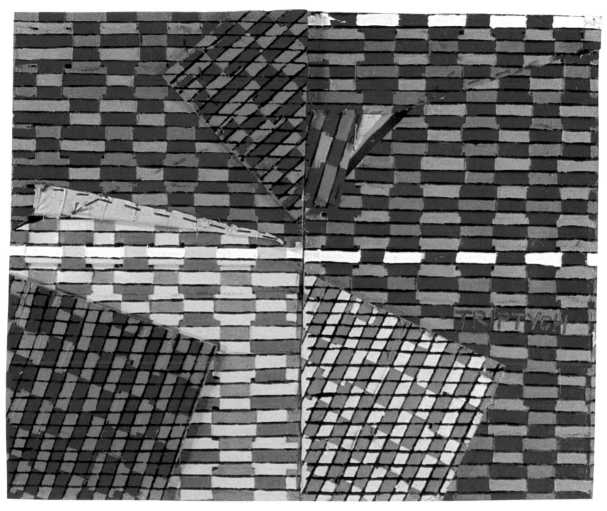

● **Triptych** *1974*
*relief construction of oil paint on interwoven
canvas strips, partly sewn with garden twine
on wood battens 60 × 72 × 2¾ (152.2 ×
183 × 7)*
The Trustees of the Tate Gallery
cat. 28

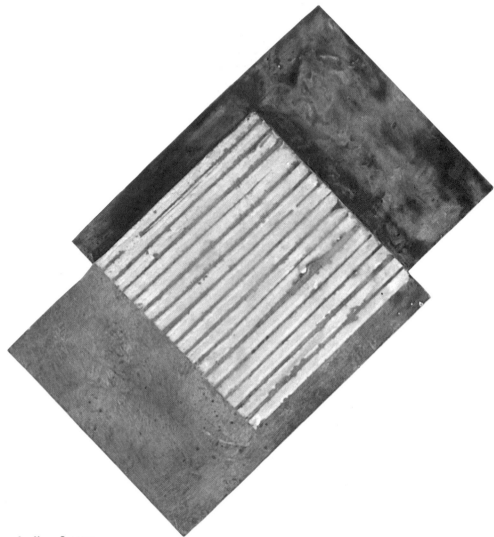

● **Concluding 3** *1977*
wax encaustic on board 27 × 25 (68 × 64)
Vivienne Guinness *cat. 33*

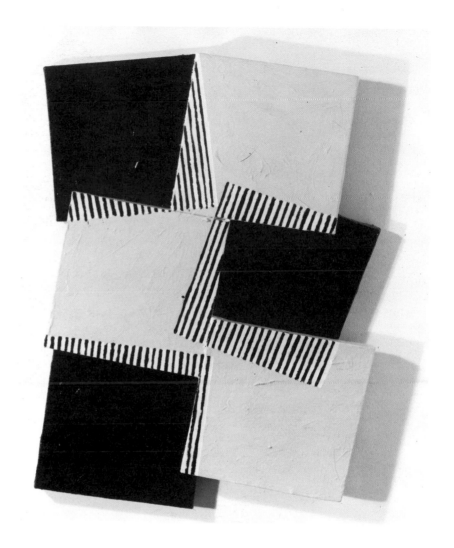

● **Small Painting no. 26** *1978*
*Polyurethane varnish over acrylic on canvas
and wood 29 × 20 × 2 (73.5 × 56 × 5)*
Saatchi and Saatchi Company *cat. 34*

Nos. 33 and 34 are representative of a great
number of small paintings made around the
same theme in 1977 and 1978.

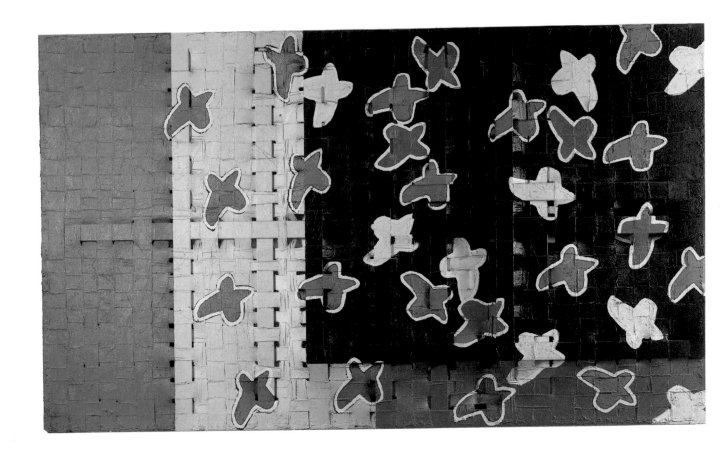

● **Dancers** 1975
*oil on canvas 60 × 100 × 4 (165 × 254 ×
10)* Saatchi and Saatchi Company *cat. 29*

The canvas interweaves the four stretchers
with the motif indicating the underlying col-
ours.

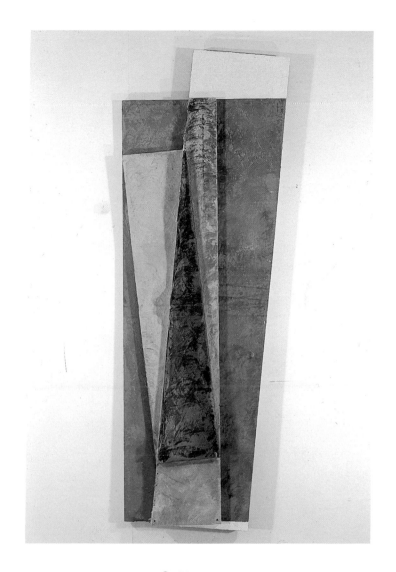

● **Share** *1978*
oil on canvas 91 × 28.5 (231 × 72)
J. Kasmin *cat. 35*

Three superimposed panels cut and reassembled.

53

Head of a Young Girl no. 1 1974 (oblique view).

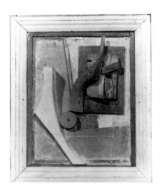

Kurt Schwitters. **Many Angles** c. 1943-4. Oil and relief on wood 19½ × 16¼ × 4″. Trustees of the Tate Gallery.

variants, consists of four separate stretchers which have been woven together with interlaced bandages of canvas. Its object quality is emphasized by the blatant exposure of the physical components, made all the more obvious by the aggressiveness with which the painting juts out from the wall, allowing a useful glimpse of the underlying construction. Along the edges of the stretcher can be seen the first coat of paint upon which the other, intuitively selected, colours have been superimposed. Each of the four square stretchers is picked out visually by a particular combination of colours and decorative patterns. The 'Cuboid' title came after the fact, when Buckley was reminded of Picasso's paper sculptures, later made in concrete; in the twilight the painting also made him think of paintings of faces by Alexis von Jawlensky.

By making explicit in such paintings not only the Cubist facetting and interpenetration of planes but also the suggestions of multiple viewpoints in those pioneering works, Buckley makes the viewer witness simultaneously to the front, sides and back of the construction. Imaginary movement gives way to literal motion, since the spectator's apprehension of the structure changes with his position. The overlay of a seductive decorative pattern — adapted from devices in the 'Rococo' phase of Picasso's Cubist work of about 1914 onwards — stresses the flatness of each canvas surface, defining each plane as a separate entity in order to focus attention on the three-dimensional nature of the work as a whole.

A thread of historical consciousness, tempered by personal enthusiasms, runs through Buckley's work of the early to mid-1970s. Two works, **The View at Arles** (1972) and **Japonaiserie** (1973), were based on specific paintings by Vincent van Gogh; in the case of the latter, he worked from a postcard reproduction of **Japonaiserie: The Flowering Plum-Tree (after Hiroshige)** 1887, which itself was a transcription of a newly-fashionable Japanese woodblock print. **Many Angles** (1972) takes its title from an assemblage by Kurt Schwitters in the collection of the Tate Gallery. 'It could have been called a

Crazy Paving picture, but I didn't want to use the title again. I think the title emerged as the work emerged, because I used quite a lot of mending plates in it, many of which are angles, and then I immediately associated it with the Schwitters title. I think I said to myself 'many angles' and remembered the Schwitters at the same moment that I was looking at the mending plates, way before the picture was finished. Then I decided to have that name plate made and put on the bottom of it, fixing the title on the thing.'

Dancers (1975), though reminiscent of Matisse's **La Danse** (1909) both in its curvilinear shapes and in its flat areas of vivid colour, makes specific reference to a painting by another early hero, Francis Picabia. 'There's a little Picabia in the Tate called **Conversation**, a title which I also used in other paintings which are more directly related. It has figures floating and is like a pictorial exercise. There used to be a standard drawing exercise with an animal cage, where if you did the bars in pencil, they looked as if the animal was in front of it, even though you'd drawn in front of the animal.' **Dancers** prompted the theme of another painting executed in the following year, **Three Figures**

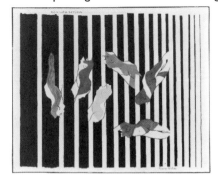

Francis Picabia. **Conversation** c. 1922. Watercolour and wash on board 23⅜ × 28½″. Trustees of the Tate Gallery.

Anchorage *1979*
wax encaustic on canvas 75 × 57½ × 3¾
(190.2 × 146 × 9.4)
Whitworth Art Gallery, University of Manchester *cat. 36*

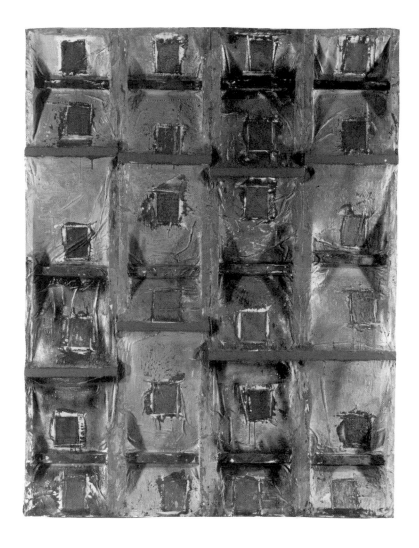

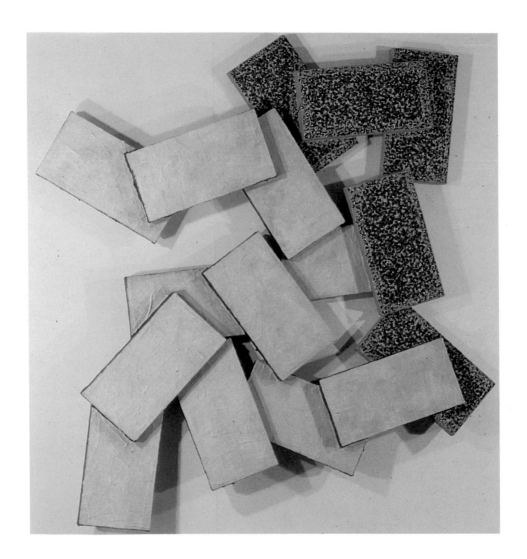

● **Java** *1980*
oil on construction of wood, canvas and hardboard 79¼ × 78 × 5 (201.6 × 198.1)
The Trustees of the Tate Gallery
cat. 37

The dots are the theme and the rest of the work the orchestration.

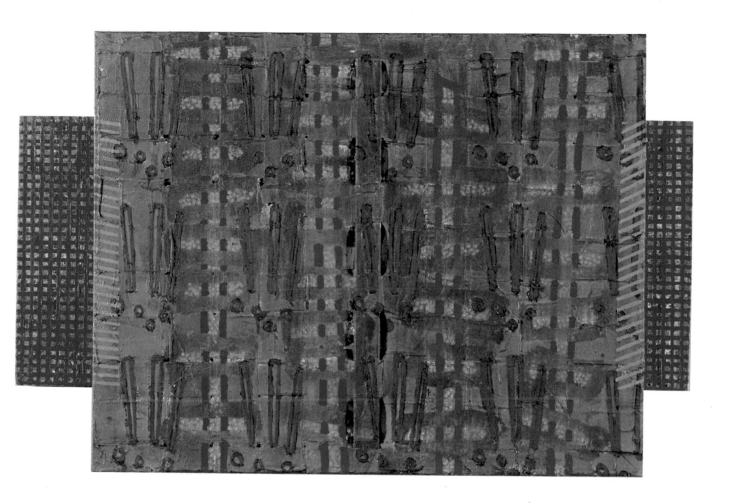

● **Cadenabbia** *1981*
oil on canvas 35⅞ × 55 (91 × 140)
Janet and Michael Green *cat. 38*

A resort on Lake Como fashionable in September during the early years of this century.

● **Two Step** *1981*
oil and enamel on canvas 38 × 16 (96.5 × 40.5) Private Collection *cat. 39*

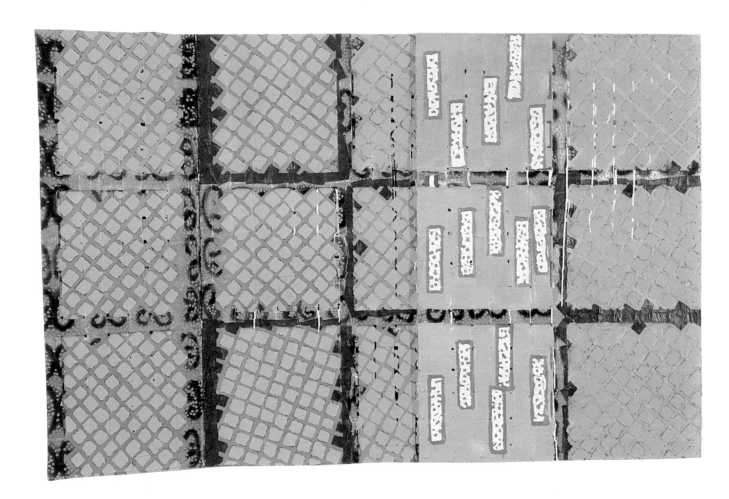

● **With Pipes and Drums** _1981_
oil and enamel on canvas 72 × 109 (183 ×
277) Knoedler Kasmin Ltd. _cat. 40_

Of three panels, each 72 × 48, the left one is
cut in half and reassembled back to back, hing-
ed to the right panel and restrained from
swinging fully out by a chain to the wall.

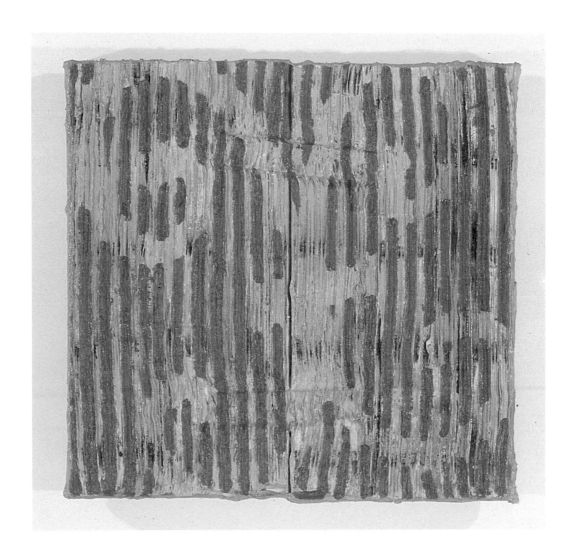

● **Sketch from a Painting** *1982*
oil on canvas on board 11 × 11.5 (28 × 29)
Caroline and Terence Conran *cat. 41*

Motif used in the painting **Béla** 1981 (72 × 120″).

Dancing, in response to a request by R.B. Kitaj to produce a figure painting for inclusion in the Arts Council exhibition, **The Human Clay**, which he was then organising. 'I was just going to do one person and then I realised the connection with how I'd split things up "exploded" the canvas, and that there would have to be more than one figure in it, although it's actually the same person: Peter Logan. I just told him to lie on a piece of board and then I drew around him and cut it out. I did a trial on a piece of hardboard first, and then I did it on canvas.'

It was during the period that he was producing works with such an evident historical reference that Buckley was quoted as saying that painting was now as much an act of scholarship for the spectator as it was for the artist himself. Both this remark and the paintings to which it relates were eagerly taken up by critics and reviewers and applied indiscriminately to Buckley's work as a whole; though it has led to great misconceptions, such a critical approach is understandable in view of the ambiguity and difficulty of Buckley's work in general, which evades conventional interpretation. The artist, however, is now anxious to put the record straight. '"Scholarship" may be an over-dramatic word to use now. What I meant was that good art is not something that is handed to you on a plate. If you think of a great piece of music, you have to concentrate on it; concentration is what I meant.' Always careful not to sacrifice the freshness and sensual immediacy of his paintings to academic considerations, Buckley has never presupposed an extensive art historical knowledge on the part of his audience. He thinks that too great an obsession with source-hunting, in fact, can get in the way. 'People who are historians or are too academic might not be able to see the wood for the trees. I think there's enough in the paintings for grade A and post-graduate, for a beginner or a scholar to enjoy.'

The historical quotations may well have been prompted in January 1972, shortly before Buckley took up the Cambridge residency, by a discussion with David Hockney about the function of representational drawing. 'I had a studio at Fitzroy Road and I was between billets at the time and staying with David. He was having an argument with himself about drawing at that time, and his work had got to the point where it was becoming very academic. I painted **The View at Arles** as a response to that argument.' Anxious to prove to himself that he could produce a convincing depiction if he so wished, Buckley decided to paint a replica from memory of a famous van Gogh painting which he had known as a child, since a reproduction of it had hung in his home. Once he had completed the facsimile to his own satisfaction, he decided that it was time that he should turn it into a painting of his own, so he obliterated the image with an electric sanding machine. He did not intend this as an iconoclastic gesture; it just seemed a necessary step to take. Once he had stitched up the tears to the canvas which had been caused by the sanding, he varnished the painting with a rich yellow to bring back to the surface the reference to the van Gogh painting which had started him off.

It is something of a historical accident that Buckley remains

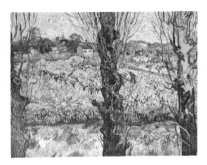

Vincent van Gogh. **The View at Arles** 1889. Oil on canvas 72 × 92 cm. Neue Pinacothek, Munich.

most associated with his work of the mid-1970s, particularly with the aggressively three-dimensional Cubist-derived paintings such as **La Manche** (1974) and the **Heads**, for it was at this time that his paintings were receiving their greatest exposure. 'I was seen around a great deal,' agrees Buckley, 'like in the Hayward show and in various British Council shows. Also that work was very accessible to students to imitate. There was a year where you couldn't go into an art school without seeing things being torn up and put back together. That's stopped now, thank goodness. They probably got bored! I think that one of the things that people will now become aware of is that there is a more consistent line of work, and that is a tangent of it rather than a backbone.'

La Manche, painted in the spring of 1974 towards the end of Buckley's two-year residency, measures nearly eighteen feet in width and is the artist's largest painting to date. Scale, for him, has been largely the product of practical necessity, and none of the studios which he has occupied since leaving Cambridge have had dimensions suitable for the production of such large-scale canvases: for six months after leaving Cambridge, Buckley lived and worked in Brede, near Rye, Sussex, in a house borrowed from a friend; in March 1975, through the offices of architect and art collector Max Gordon, he moved into a studio at Butler's Wharf, London, which although one hundred feet in depth was split into twelve-foot bays with a ceiling height of only eight feet. Since January 1978 he has worked in the basement of the terraced house which be bought at that time in Clapham, South London. Buckley admits that he would like to be able to produce a very large painting every now and then, but as always his attitude is a pragmatic one, and he is prepared to make the best of the constraints imposed by his working conditions. He sees no essential difference between paintings of contrasting scale. 'I don't think you could read too much into the different sizes. I like to think that the size of each work, however large or small, has come about because that's the way it's got to be. What I feel I want to begin that day has got to be that sort of size.'

The title of **La Manche**, as in so many other cases, provides

● **Flons-Flons** *1982*
oil on canvas 24 × 48 (61 × 122)
Sven Gahlin *cat. 42*

The first of five paintings and a screenprint
using this title.

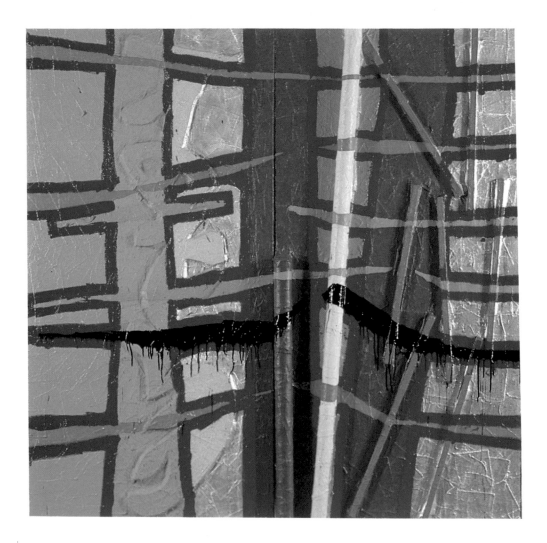

● **Bean Poles** *1983*
oil and enamel on canvas, cardboard tubing and wood 72 × 72 (183 × 183) (two panels 72 × 36) Knoedler Kasmin Ltd. *cat.* 45

The ancillary poles which stretch outwards the roof of the Big Top are known in circus jargon as 'bean poles'. There are several monotypes of the same name.

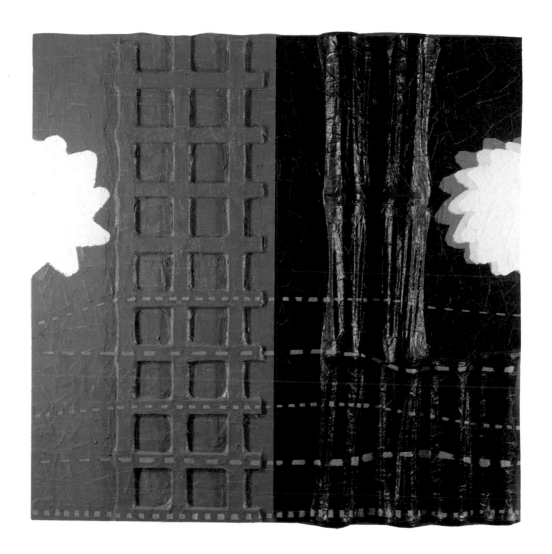

● **The Last Terrace** *1983*
oil and liquid linoleum on canvas and wood
72 × 72 (183 × 183) (two panels 72 ×
36)
Knoedler Kasmin Ltd. *cat.* 47

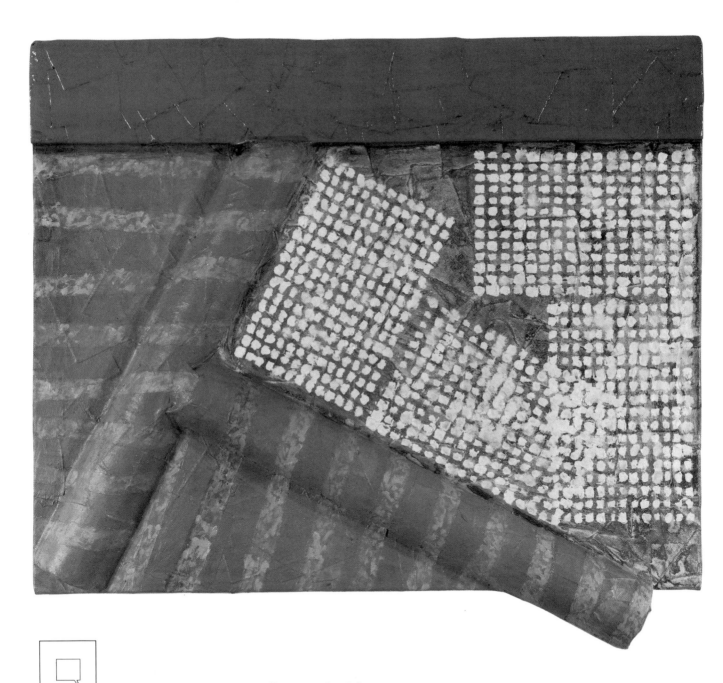

● **After Poelzig** *1983*
oil on linoleum paint on canvas and card-
board tubing 37 × 41 (94 × 104)
Christopher Taylor *cat. 43*

The second of several paintings named for the
German architect Hans Poelzig.

● **Metro** *1983*
oil and acrylic on canvas on wood 45 × 31
(114 × 79) Knoedler Kasmin Ltd. *cat. 44*

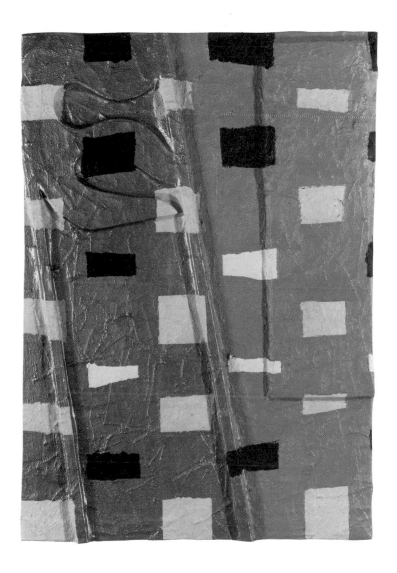

Metro seems to be the name of many things
— bars, cinemas, sports outfitters, etc., as well
as the Paris underground railway.

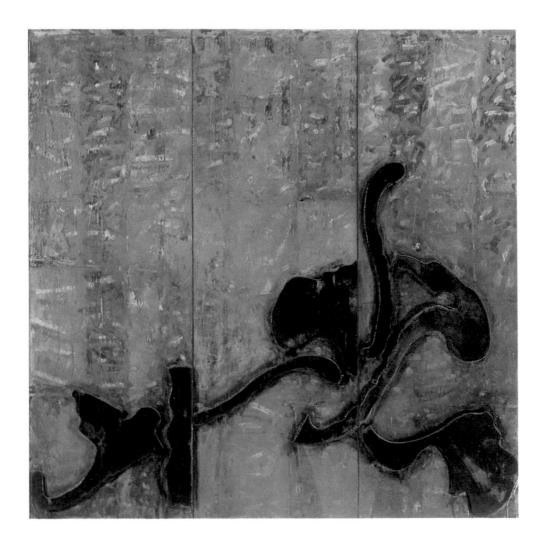

● **Mahwari** *1983*
linoleum paint on wood, polyurethane varnish
over casein on hardboard panels 72 × 72
(183 × 183) (three panels 72 × 24)
Janet and Michael Green *cat. 48*

Invented name which could be a range of
mountains in Africa or a river in Asia.

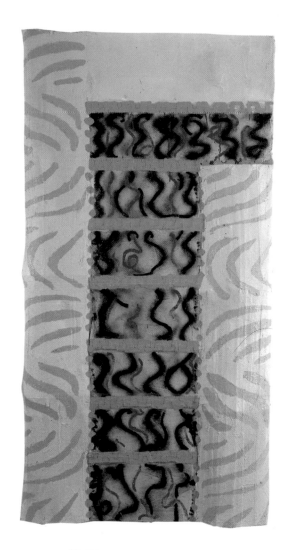

● **Tut** *1984*
oil on canvas 83 × 43 (211 × 109)
Janet and Michael Green *cat. 50*

'Tut' is the name of a steamer on the Nile.

clues to the factors which motivated the artist in making it and to possible readings which can serve the spectator in experiencing it. The linguistic ambiguity of Buckley's titles as far back as **Dos** (1968) is appropriate to the spirit of the work, for it provides a parallel to the often highly subjective response occasioned by the paintings themselves. Translated from the French, 'La Manche' can mean either the English Channel or a sleeve — or, more usefully, both these things. Buckley says that in making this picture, which consists of three linked groups of four interlaced stretchers, he had in mind the frantic interweaving of fighter planes engaged in a 'dogfight'. 'That's why I called it **La Manche**, because the Battle of Britain took place over the Channel. It's a very tenuous connection, but that was the stream of thought which gave it the title.' It would be tempting to interpret the geographical reference in another sense, as well, as an avowal of the cross-cultural identity of the marks painted on the surface, which are as reminiscent of 'French marks' or of Russian Suprematist abstractions as they are of German airplanes. Though this was not a conscious intention on the part of the artist, he concedes that, because of the deliberate openness of meaning, such alternative views may also be valid.

After leaving Sussex in early 1975, Buckley and his wife lived for a short period in the house of painter Howard Hodgkin, near Holland Park, while they waited to move into a housing co-operative on the Isle of Dogs in East London. This period at Holland Park brought him into close contact with two other

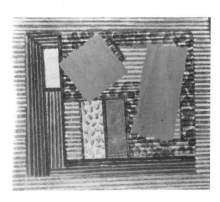

Howard Hodgkin. **Interior with a Painting by Stephen Buckley** 1975-76. Oil on wood 124.5 × 144.8 cm. J. Sainsbury plc, London.

painters: Mick Moon, who was working in the same house, and Patrick Caulfield, who lived nearby and often dropped in to visit. Hodgkin's intimate abstract paintings, rooted in memories of private domestic occasions and in encounters between people, rely, like Buckley's work, on lusciousness of colour, a simplicity of mark and a willingness to court crudeness for the sake of

intensity of effect. Though Hodgkin and Buckley have strong individual identities — in their choice of materials (Hodgkin paints exclusively in oils, generally on a wooden support), scale and subject matter — there is a sufficient kinship between the work of the two artists for such a comparison to have been made on repeated occasions.

'I think the difference between Howard Hodgkin and me is that Howard intends to paint a Hodgkin every time he paints a picture, and I think I intend to make a painting every time I start. I think that the people who have made that comparison have realised, without formulating it completely, that my work isn't really abstract in the way that his wasn't before he started saying that he was a figurative artist; he used to call himself an abstract artist. They've realised that we're both on the cusp, as it were. So I think that's an instinctive comparison, because they can't quite categorise us.'

In the decade or so since Buckley established himself as one of the leading artists of his generation in Britain, he has continued to elaborate a rich personal idiom with increasing refinement and subtlety. The compulsion to dismantle the conventions of his chosen medium have gradually waned, as with each group of paintings he replaced established methods which did not suit him with devices of his own making. Today he is much more comfortable about describing himself as a painter than he would have been in the late 1960s, when he considered himself to be a fabricator of objects; the apparent aggression of the early work has correspondingly given way to a more tranquil hedonism.

'The closer it gets to one's current experience,' Buckley observes, 'the harder it gets to explain what one is doing. There is probably a ten-year gap before I begin to understand myself.' It is clear to him, nevertheless, that his work *is* in a constant state of flux, and it is thus a source of irritation to him that reviews of his work have relied to such an extent on preconceived notions. 'They've been repetitive to the point that people got their actual facts wrong, sometimes, and said things about an exhibition which just aren't there — like stitching. They'd make an assumption that I'd done something in a certain way because I'd done it that way before, whereas superficially I'd done it that way, but when you examine it you realise I *haven't* done it that way because I've done that before: so I've done something similar.'

Although traditional oil paint and canvas have been the primary materials of Buckley's paintings since the late 1970s, the artist remains as prepared as ever to make use of new substances if the effects he seeks seem to call for them. Recently, for instance, he has taken to cardboard tubing and plastic drainpipes as constructive elements with which to make interesting shapes, which he then covers with a continuous surface of linoleum paint and a final layer of oil colour. 'The liquid linoleum came about for practical reasons, originally, in that it was a very useful paint which was neither gloss nor matt. It was reasonably cheap in terms of volume — it isn't cheap paint, but in comparison to artist's colour it *is* cheap — and it's also extremely hard and

Attendant *1983*
oil and linoleum paint and canvas on plywood
panel 80 × 32 (203 × 81)
Waddington Galleries Ltd. *cat.* 46

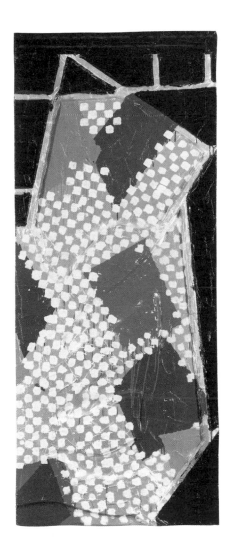

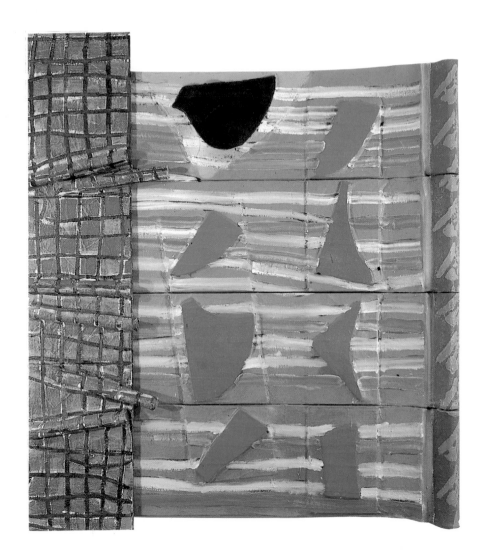

● **Avalon** *1984*
oil on acrylic on canvas and cardboard tubing
90 × 80 × 8 (228.5 × 203 × 20)
Knoedler Kasmin Ltd. *cat. 52*

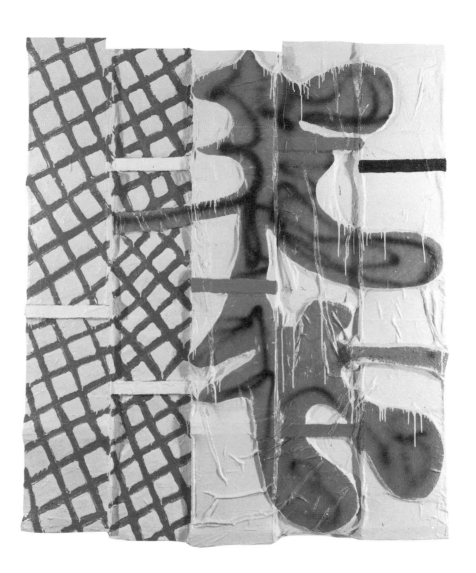

● **The Other Side** *1984*
*oil on linoleum paint on canvas 74 × 60
(188 × 152.2)*
Knoedler Kasmin Ltd. *cat. 49*

durable, because it's made to go on floors. So on a canvas that was quite moulded you could do a base surface, perhaps, or even keep it as the top surface; it exists in quite a few paintings. It really toughens the surface that was there, and there's a sufficient elasticity in it for it not to crack.'

The spirit of improvisation which has guided Buckley from the beginning shows no signs of abating. In 1975 he made a painting measuring 74 × 84 inches on which three wooden bars intersected at diagonals across the canvas surface; he titled it **Splash** because it seemed a 'splashy' sort of painting and because the term was also one used by photographers to describe an exploding light effect off a spotlight. He was amused, too, to borrow a title which had featured in three Hockney swimming pool paintings of 1966-1967, particularly as the filmed biography of Hockney titled **A Bigger Splash** had just been released. Later in the year this led to another painting, **Splash no. 2**, which borrows devices from the Picabia **Conversation** referred to earlier in relation to **Dancers**. In a slightly later painting, **Anchorage** (1979), the canvas surface juts in and out as if seeking to free itself from the stretcher bars which clamp it down. The framework around which the canvas is woven acts as a stabilising element, securely 'anchoring' the agitated sense of movement. The impulsive action conveyed by the construction of the picture provides evidence of the artist's physical exertions in making it. The dry-looking wax encaustic medium, however, appears to freeze the brushstrokes into rigid stillness, drawing attention to the static quality of the painting as a finished object.

Musings about architecture, which have been a recurring theme with Buckley since the time of his first painting, **Middle Class Interior with Ballroom** (1963), come to the fore again in a group of paintings begun in 1981: **Cadenabbia, Como, With Pipes and Drums** and **Béla**. All of these contain frag-

Pots and Pans 1983. Liquid linoleum on canvas and wood (two panels) 72 × 72 (183 × 183). Private collection, New York.

ments of turn of the century architecture — iron balustrades and the like — associated with Italian lakeside resorts fashionable in that period. Buckley had driven through such places on holiday but began thinking about them again because of the anonymous novel, **Madame Solario**, which he was reading at that time. 'Whilst reading the book I began to think about the architecture. I looked it up here and there in books to see what it looked like, to refresh my memory.' Two years later, Buckley dedicated a pair of paintings to Hans Poelzig, the German architect active from the second decade of this century through to the 1930s. Buckley, who is a great admirer of his theatres and cinemas, painted the first of these canvases, **Poelzig**, in a luscious pink because he wanted his picture to be as sensuous and erotic as the buildings to which it alluded. The title of the second painting, **After Poelzig**, declares its relationship both with the previous picture and with the architectural forms in question. Architecture of a rather more transient, if no less festive, sort, lends it aura to **Bean Poles** (1983), the title of which refers to the auxiliary poles which spread out the sides of 'Big Top' tents in circuses.

Two of the paintings with Italian architectural elements, **Béla**

Béla 1981. Oil on canvas 72 × 120 (183 × 305). Brooke Alexander Inc., New York.

and **With Pipes and Drums**, make reference also to the music of Hungarian composer Béla Bartók, which Buckley had long admired but which he was listening to in depth at that time; the title of the latter is the name of one of Bartók's pieces. In 1977 Buckley had made a painting, measuring only 14½ × 14½ inches, which he titled **Foxtrot** because its intersecting bands of colour reminded him of Mondrian's 1940s paintings of New York such as **Broadway Boogie-Woogie**. This, in turn, led to other pictures which took as their titles the names of dances: **Quickstep** (1977), followed later by **Two Step** (1981) and **Turkey Dance** (1981). Tenuous though the connections may be, music and dance provide apt metaphors for the light touch and spirit of the paintings of this period.

Java (1980), which in its hint of a running figure looks back to **Three Figures Dancing** (1976) and forward to the humanoid form in the right-hand section of **The Other Side** (1984), introduces another theme: that of Eastern exoticism. The title in this case was an arbitrary one, but a deliberate oriental flavour was soon to emerge in paintings such as **Pots and Pans** (1983), in which the cut-out shapes, copied from an old photograph of an oriental market stall, spell out the words in Chinese characters. Another painting, **Mahwari** (1983), is constructed out of wood in the manner of an oriental screen, though it hangs flat on the wall. 'I'd been doing a few panel pictures, like **Pots and Pans, Bean Poles** and **The Last Terrace**, which were all fabricated in a similar sort of way, and I felt an urge to try a different way. **Mahwari** was made of three 24" panels, so that it actually came out the same size as the others, but I wanted to try and make it physically slightly different, but connected with the work I was doing. So that's why it looks the way it does. It

Monday I 1982. Lithographic monotype on paper 35¼ × 50 (89.5 × 127). Knoedler Kasmin Ltd.

was really just a decision to make a change. Also I did have an idea, which didn't work, that I was going to try and do it very delicately painted, stained into the wood. But the colour sank too far, so I just took it from there and produced what you see.'

In September 1982 Buckley spent a week making monotypes at Sky Studios, London, run by Alan Cox. The pressure to work quickly and spontaneously had a salutary effect on him when he returned to his paintings, some of which — like the later works in the **Flons-Flons** series — he sensed had been in danger of being overpainted and too rigidly controlled. 'It's also very liberating sometimes to be working away from one's own studio in some other situation, at times, so if there's anything lying around the studio and you don't have time to look at it, when you finally come back to it, you're fresh. It's like a little holiday.'

Buckley's most recent works are marked by a return to the looser, more improvisational approach of his early paintings, but rephrased in a lusciously decorative idiom which is unapologetically seductive. The sly reference to the splendours of King Tutankhamen's tomb in **Tut** (1984) is ably supported by the dazzling yellow and gold colour scheme as well as by the very structure of the painting as an entrance or architectural enclosure. The title of **Avalon** (1984) — an allusion not only to the 'knight's heaven' of Arthurian legend, but also to a town in France known for the excellence of its restaurants — suits well a painting which is at once calming and almost indecently satisfying to the senses. It is a title which he had had in mind to use for some time, though his old friend Bryan Ferry beat him to it in 1982, when he took it as the name of a Roxy Music song and album. Buckley was not put off by this; Avalon, after all, was also the name of an American town which had been the subject of a tune performed by Benny Goodman. 'It's just a passing reference to other worlds,' he remarks, 'to other worlds connected.'

In the mid-1970s, Buckley was a centre of attention in the British art world. Since then, although he continues to be held in great respect and to sell his paintings internationally, he seems to have fallen out of favour to a certain extent with the art establishment in his country — or perhaps it would be more accurate to say that some of the attention which used to be directed at him has now shifted to younger and more fashionable painters. The situation does not worry him unduly, since he has never felt the need to align himself with a group movement, preferring to continue on his own path. 'I've gone on working the way I work because I've had sufficient self-confidence, apart from some early times, to trust my own judgment and my own eyes. Obviously one has periods of doubts, but in general I feel I've had the confidence to carry on, with the support of Kas, of a small group of artists and of various people whose judgment I trust. There has been a sufficient group of friends to keep me going.' Just as Buckley has been sustained by his faith in himself, so has his work as a painter drawn strength from its spirit and from its independence of fashion.

Marco Livingstone
Oxford, January 1985

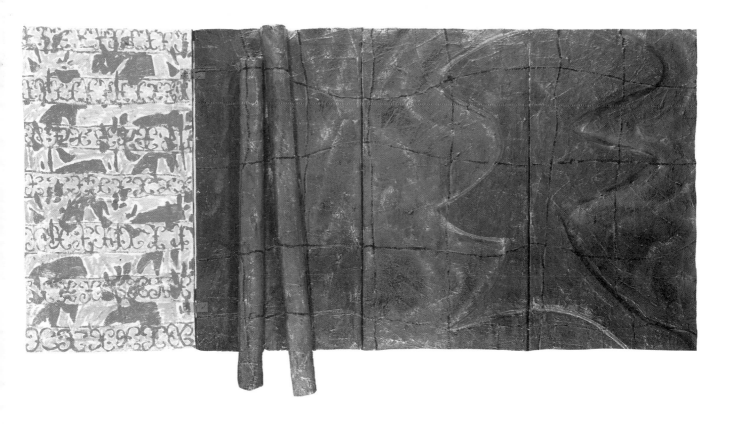

The extreme left hand panel of four is hinged
to the second and takes its own balance.

● **Tafel** 1984
*oil colour on canvas, fibreboard and plastic
tubing 55 × 96 (140 × 244)*
Knoedler Kasmin Ltd. *cat. 51*

Notes

[1] 'Stephen Buckley interviewed by James Faure Walker,' **Artscribe** no. 9, November 1977, p.9-12, and 'Stephen Buckley interviewed by Tony Godfrey,' **Artlog** 2, November 1978. All quotations in the present study are from an interview with the author which took place on 18 January 1985.

[2] Smith's 1963 Kasmin exhibition was among those reconstructed in **Richard Smith: Seven Exhibitions 1961-75**, Tate Gallery, London, 1975, the catalogue for which includes a critical essay by Barbara Rose. See also the interview between Smith and Bryan Robertson in the catalogue of the exhibition **Richard Smith: paintings 1958-1966**, Whitechapel Gallery, London, May 1966.

[3] For an exposition of the course structure, see David Thistlewood, **A Continuing Process**, exhibition catalogue, Institute of Contemporary Arts, London, 1982.

[4] 'There was also a lively poetry scene in Newcastle,' recalls Buckley, 'centred around Tom Pickard, who had rediscovered Basil Bunting and opened the Morden Tower Bookroom, and he was bringing people like Ferlinghetti and Ginsberg to Newcastle in the 'sixties. It was a busy time, there was a lot to do.'

[5] The Picabia exhibition took place at the Hatton Art Gallery in 1964 and was also shown at the Institute of Contemporary Arts, London. **The Almost Complete Works of Marcel Duchamp** was the title of the Tate exhibition held in 1966; **The Bride Stripped Bare by her Bachelors, Even** was the subject of a separate exhibition held at the Hatton Art Gallery in the same year.

[6] Quoted in **6 Artists selected by William Varley**, Gulbenkian Gallery of the People's Theatre, Newcastle, exhibition leaflet, 3-24 December 1973.

[7] **Schwitters**, Marlborough Fine Art, London, March-April 1963. The only work then owned by the Tate Gallery was **Opened by Customs** c. 1937-9 (TG T.214).

[8] Hamilton's book, **The Bride Stripped Bare by her Bachelors, Even**, which incorporated a translation by George Heard Hamilton of Duchamp's **Green Box**, was originally published in 1960 by Percy Lund, Humphries and Co. Ltd., London and Bradford, with a second printing by the same publishers in 1963. It has since been republished by Edition

Hansjörg Mayer, Stuttgart, London, and Reykjavik, 1976.

[9] 'The people that stand out for me in this century so far are Duchamp and Matisse, followed by Johns — that should explain something,' commented Buckley in the 1978 **Artlog** interview. He went on to make some essential distinctions between his work and that of the American. 'Johns works mostly on a grand scale and uses graphic work to extend it, which I don't — my graphic work tends to be incidental — and my painting is intimate and non-figurative which his isn't. His appears to be very much about a considered philosophy and I do not have such a clearly defined one. I think I felt I understood his paintings when I was ten years younger rather better than I do now — the same paintings that I saw then, now seem very different, perhaps that's because I'm more engaged in painting, rather than *art*, than I was then. I think my character is extremely different from his: he seems more rigorous in analysis than I can be. I think he *does* translate: it seems possible to *say* what he's done. I find it very hard to *say* what I've done. Originally I was enormously influenced by him, but less now directly. I think his achievements are a constant, always in the air and at the back of one's mind.' Though Buckley's urge to reveal, within the paintings themselves, evidence of the processes by which they were made has roots within Johns's work, it is worth noting that certain devices and types of imagery occur earlier in Buckley's work than in that of the older artist. The crazy paving theme first dealt with by Buckley in 1968, for instance, was introduced into Johns's painting four years later in **Untitled** 1972 (Museum Ludwig, Cologne); the left-hand panel of this painting by Johns, the first instance of the patchwork of clusters of lines which was to become a major feature of his paintings of the mid 1970s, bears a coincidental resemblance to Buckley's **Trullisatio**, painted in the same year.

[10] The most famous example, Warhol's **Chelsea Girls**, was not made until 1966.

[11] See note 2.

[12] A full account of the making of **Triptych** (1974) is included in the entry on this painting in **The Tate Gallery 1974-6: Illustrated Catalogue of Acquisitions**, 1978, p. 65-66.

[13] The original painting from which **Head of a Young Girl no. 7** was made, **Combwich** (1973) (36 × 120″), is illustrated in **Cambridge Works by Stephen Buckley**, exhibition catalogue, Kettles Yard Gallery, Cambridge, 16 February-10 March 1974, cat. 19.

[14] In this Buckley's work is linked in spirit with that of another British abstract painter of a slightly older generation, Bernard Cohen, even though he himself is largely unaware of the similar bias in Cohen's pictures. See the essay by Richard Morphet in **Bernard Cohen: paintings and drawings 1959-71**, exhibition catalogue, Arts Council of Great Britain, 1972.

[15] As Buckley points out, the shaped canvases, for instance, of Jeremy Moon (1934-1973), with which his have frequently been compared, were first drawn out as shapes on paper and then enlarged; see **Jeremy Moon: paintings & drawings 1962-1973**, Arts Council of Great Britain, 1976. Buckley himself never makes such preparatory drawings, apart from an occasional thumbnail sketch to work out how things might fit together, since he prefers the paintings to take form through a direct manipulation of the materials. The methods used by Richard Smith in the 1960s and early 1970s, like Moon's, entailed strict initial decisions about the form of each piece which allowed no real room for improvisation; it was only after Smith abandoned stretchers in 1972 for aluminium rods that the possibility existed of the canvas finding its own position. Closer in spirit to this aspect of Buckley's work are Robert Morris's felt pieces of the late 1960s, exhibited as part of his retrospective at the Tate Gallery in 1971, and Frank Stella's black and grey paintings of 1958-60, a group of which he had seen and admired at the Kasmin Gallery in 1964; these were characterised by an austere geometry of bands of paint which articulated the underlying structure of the stretched canvas.

[16] The comparisons with each other's work which have plagued both Buckley and Milow had their origins in chance circumstance: not ony were they associated because of the Hayward Gallery and Nigel Greenwood connections, they were sometimes even mistaken for each other by unobservant people. In the early 1970s, when they both had studios near Old Street station in London, they saw more of each other socially than they have in the years since then. Milow now lives and works in New York.

Exhibitions

Lenders to the Exhibition

the artist

Aberdeen Art Gallery and Museums

Michael Abrams

Arts Council of Great Britain

The British Council

Brooke Alexander, Inc.

Scarlet Buckley

Caroline and Terence Conran

Sven Gahlin

Max Gordon

Janet and Michael Green

Nigel Greenwood Gallery

Vivienne Guinness

David Hockney

Stephanie James

J. Kasmin

Knoedler Kasmin Gallery

Merseyside County Council: Walker Art Gallery Liverpool

Saatchi and Saatchi Company

Nikos Stangos and David Plante

Christopher Taylor

The Trustees of the Tate Gallery

Waddington Galleries Ltd.

Whitworth Art Gallery, University of Manchester

and private collectors who wish to remain anonymous

One-Man Exhibitions

1966 Durham University

1970 Nigel Greenwood Inc., London

1972 Hans Neuendorf Gallery, Cologne
Hans Neuendorf Gallery, Hamburg
King's College, Cambridge
Kasmin Gallery, London

1973 *Galleria dell'Ariete, Milan

1974 *Kettle's Yard Gallery, University of Cambridge
Garage Art Ltd., Covent Garden, London

1975 Jacomo-Santiveri, Paris
Museum of Modern Art, Oxford

1976 Kasmin Ltd. at Waddington Galleries

1977 Arnolfini Gallery, Bristol
Aberdeen Art Gallery
Turnpike Gallery, Leigh, Greater Manchester
Bologna Art Fair

1978 Robert Elkon Gallery, New York

Museum of Modern Art, Oxford, September 1975.

Anthony Stokes Ltd. (etchings and lithographs)
Galleri Malmgran, Gothenburg, Sweden
Knoedler Gallery, London
Hobson Gallery, Cambridge (prints)
Arnolfini Gallery, Bristol (prints)

1980 Knoedler Gallery, London
Amano Gallery, Osaka, Japan
Bernard Jacobson, London (etchings)

1981 Brooke Alexander, New York
Knoedler Gallery, London

1982 LA Louver, Los Angeles
Knoedler Gallery, London (monotypes)

1983 Brooke Alexander, New York
Knoedler Gallery, London

1984 Thorden and Wetterling Galleries, Gothenburg
Festival Gallery, Bath (small paintings and large monotypes)

1985 Museum of Modern Art, Oxford (retrospective)

Knoedler Gallery, London, October 1983.

Arts Council of Northern Ireland Gallery, Belfast (retrospective)
Walker Art Gallery, Liverpool (retrospective)
Brooke Alexander, New York (early paintings)
Clock Tower, New York (work from American collections)
Yale Center for British Art, New Haven, Connecticut (work from American collections)

Group Exhibitions

1968 **Northern Young Contemporaries**, Whitworth Art gallery, University of Manchester (prizewinner)

1969 Greenwich Art Gallery, London
***6 at the Hayward,** Hayward Gallery, London

1970 Richard Demarco Gallery, Edinburgh
Manchester City Art Gallery
Museum of Modern Art, New York

1973 ***La Peinture Anglaise Aujourd'hui,** Musée d'Art Moderne de la Ville de Paris
***Objects and Documents,** Arts Council of Great Britain touring exhibition (1972-73)
8e Biennale, Paris
***Henry Moore to Gilbert and George** (Modern British Art from the Tate Gallery), Palais des Beaux-Arts, Brussels
***Critics Choice,** Gulbenkian Gallery, Newcastle-upon-Tyne
Tables, Garage Art, Covent Garden, London

1974 **John Moores Liverpool Exhibition 9,** Walker Art Gallery, Liverpool (prizewinner)
mixed drawing exhibition, DM Gallery, London
British Painting '74, Hayward Gallery, London
***Four Figures,** Eastern Arts Association touring exhibition
***Menton Biennale**

1975 **CAS Art Fair,** Mall Galleries, London
***Indian Triennale,** New Delhi
Chichester National Art Exhibition (prizewinner)

1976 ***Peintres et Sculpteurs Britanniques,** Centre Culturel de la Ville de Toulouse
British Exhibition, Basel Art Fair
***The Human Clay** (selected by R.B. Kitaj), Hayward Gallery, London and Arts Council tour (1976-77)
The Deck of Cards, JPL Gallery, London

1977 Young Hoffman Gallery, Chicago

Tolly Cobbold Exhibition, Fitzwilliam Museum, Cambridge, and tour (prizewinner)
***Hayward Annual: Part Two,** Hayward Gallery, London
Whitechapel Open, Whitechapel Art Gallery, London
***British Painting 1952-77,** Royal Academy of Arts, London
***Color en la Pintura Británica,** British Council touring exhibition in South America (1977-78)
Small Work, Newcastle-upon-Tyne Polytechnic Art Gallery

1978 Knoedler Gallery, London
Members' Choice Exhibition, Liverpool Academy of Art
***Certain Traditions: Recent British and Canadian Art,** Edmonton Art Gallery and Canadian tour (1978-79)
Aberdeen Art Gallery (prints)
Chester Art Centre (prints)
***Critics Choice,** ICA Gallery, London

1979 ***Certain Traditions: Recent British and Canadian Art,** Commonwealth Institute, London
***Un Certain Art Anglais,** Arc II, Musée d'Art Moderne de la Ville de Paris
Knoedler Gallery, London
John Moores Liverpool Exhibition 11, Walker Art Gallery, Liverpool
***Today: British painting in the 60s and 70s,** City Art Hall, Lund, Sweden
Tolly Cobbold/Eastern Arts 2nd National Exhibition, Fitzwilliam Museum, Cambridge and tour
***The British Art Show** (selected by William Packer), Mappin Art Gallery, Sheffield, and tour (Arts Council of Great Britain)
***Sydney Biennale,** Sydney, Australia

1980 ***Occasional Pieces: Chairs, tables and functional objects,** Kettle's Yard Gallery, University of Cambridge
Changing Summer Exhibition, Knoedler Gallery, London
Summer Exhibition, Brooke Alexander, New York
***The Newcastle Connection,** Newcastle-upon-Tyne Polytechnic Art Gallery
Eight New British Artists, Bernard Jacobson Ltd., New York
John Moores Liverpool Exhibition 12, Walker Art Gallery, Liverpool

1981 **Mixed exhibition of small pictures,** Knoedler Gallery, London
***Colour in British Painting,** British Council tour in Japan
Baroques 81, Musée d'Art Moderne de la Ville de Paris
***Prints by Six British Painters,** Tate Gallery, London
Tolly Cobbold/Eastern Arts 3rd National Exhibition, Fitzwilliam Museum, Cambridge and tour

1982 Knoedler Gallery, London
***An Exhibition of ten graduates 1964-74 from the Department of Fine Art, University of Reading,** University Art Gallery, Reading

1983 **Twentieth-Century Art from the Metropolitan Museum of Art: Selected Recent Acquisitions,** The Queens Museum, Flushing, New York
Aspects of Post-War Painting in Europe, Solomon R. Guggenheim Museum, New York

1985 **John Moores Liverpool Exhibition 14,** Walker Art Gallery, Liverpool (prizewinner)

Catalogues of the exhibitions marked * include essays and/or sets of reproductions of the artist's work.

Bibliography

articles and reviews

London Magazine November 1970 William Feaver, 'The New Materialism'

Evening Standard 19 October 1972 Richard Cork

Sunday Times 22 October 1972 John Russell, 'Modern Visions'

Observer 29 October 1972 Nigel Gosling, 'Icy Treasures'

Financial Times 6 November 1972 Marina Vaizey, 'Stephen Buckley at Kasmin'

Sunday Times 11 February 1973 John Russell, 'The English Conquest'

Financial Times 19 February 1973 Marina Vaizey, 'British Allsorts: Musée d'Art Moderne, Paris'

Connoisseur March 1973 Georgina Oliver, 'In the Galleries'

+−O **revue d'art contemporain** April 1974, reproductions of four works

Arts Review 3 May 1974 Peter Fuller, 'Profile of Stephen Buckley'

Art Press 1975 Lynda Morris, '8th Biennale (Paris). Stephen Buckley'

Sunday Times 18 January 1975 Marina Vaizey, 'Living Objects'

Le Monde 20 February 1975 Geneviève Breerette, 'Buckley: La peinture et son cadre'

Nouvelles L'Héraires 16 March 1975 Daniel Marchesseau, 'Quand le support fait surface . . .'

The Spectator 11 October 1975 John McEwen, 'Buckley in Midstream'

Le Monde 17 October 1975 Geneviève Breerette, 'Autour de la Biennale'

L'Humanité 8 November 1975 Raoul-Jean Moulin, 'Stephen Buckley et la déconstruction du tableau'

Observer 18 January 1976 William Feaver, review of Buckley exhibition at Waddington Galleries

Art International March/April 1976 Fenella Crichton, 'London Letter'

Studio International March/April 1976 Peter Fuller, 'Stephen Buckley'

New Society 20 May 1976 Peter Fuller, 'The Magic Circle'

Arnolfini Review January/February 1977 Peter Fuller, commentary to the exhibition, 'Stephen Buckley'

The Times 18 January 1977 Paul Overy, 'Mr. Breakwell's Diary'

Art and Artists March 1977 Paul Overy, review of Buckley exhibition at Arnolfini

Artforum April 1977 Peter Fuller, 'Troubles with British Art Now'

Artscribe no. 6 April 1977, 'Peter Fuller Responds to "Painting Now" ' and 'James Faure Walker replies'

Aberdeen Press and Journal 2 April 1977 'Unique Art Form for North East'

The Scotsman 18 April 1977 Edward Gage, 'Contemporary Frontiers'

Arts Review 27 May 1977 Neil Hanson, review of Buckley exhibition at Turnpike Gallery, Leigh, Gt. Manchester

Sunday Telegraph 24 July 1977 Michael Shepherd, 'The Better Half'

The Observer 24 July 1977 William Feaver, 'Full House'

Evening Standard 28 July 1977 Edward Lucie-Smith, 'Squeaks from the South Bank'

What's On In London 28 July 1977 Michael Shepherd, 'Second time luckier'

Time Out 29 July 1977 Terence Maloon, 'Anticlimax'

The Spectator 30 July 1977 John McEwen, 'Hardy annual'

Sunday Times 31 July 1977 Marina Vaizey, 'The Best of British'

Financial Times 1 August 1977 William Packer, 'The Hayward Annual, Part II'

The Times 2 August 1977 Paul Overy, 'Manifestations of contemporary taste'

The Times Literary Supplement 5 August 1977 Tim Hilton, 'South Bank-ruptcy'

Arts Review 5 August 1977 Frances Spalding and Janet Daley, 'Hayward Annual Part II: Two Views'

New Statesman 12 August 1977 John Spurling, 'Very Middling'

The Spectator 13 August 1977 John McEwen, 'Mixed Bag'

Artscribe no. 9. November 1977, 'Stephen Buckley interviewed by James Faure Walker'

Art/World 14 January-10 February 1978, review of Stephen Buckley's Exhibition at Robert Elkon Gallery, N.Y.

New York Times 20 January 1978 John Russell, 'Art: Charting a Jagged Terrain'

Arts Review 17 February 1978 Marina Vaizey, Review of Stephen Buckley's prints at Anthony Stokes Ltd.

The Spectator 1 April 1978 John McEwen, 'Purtiness'

The Sunday Times Magazine 2 April 1978 Christine Walker and Peter Paterson, 'Who Will Be Who in The 1980's'

Art in America July-August 1978 Roberta Smith, 'Stephen Buckley at Elkon'

The Sunday Times 16 July 1978 Marina Vaizey, 'View of a gritty new world'

Arts Review 21 July 1978 Guy Burn, 'Stephen Buckley/Kasmin at the Knoedler Gallery'

The Spectator 22 July 1978 John McEwen, 'From Structure to Surface'

The Observer 23 July 1978 William Feaver, review of Buckley exhibition at Knoedler in 'Paris Fashion'

Time Out 28 July-3 August 1978, 'Knoedler Gallery, Stephen Buckley'

Artscribe no. 13. August 1978 Terence Maloon, review of Stephen Buckley exhibition at Knoedler

Coloquio/Artes Lisbon September 1978 John Benthall, 'Letter from London'

Financial Times 16 September 1978 William Packer, 'Critic's Choice at the ICA'

The Spectator 16 September 1978 Tim Hilton, 'Anthologist'

The Times 19 September 1978 John Russell Taylor, 'Quirky but Impersonal — Critics Choice ICA'

Artlog 2 November 1978 Tony Godfrey, 'Interview with Stephen Buckley'

Artforum December 1978 John McEwen, 'Four British Painters'

The Observer 3 December 1978 William Feaver, 'A Matter of Ways and Means'

Financial Times 5 December 1978 William Packer, 'The 11th John Moores'

Arts Review 2 March 1979, 'Un certain art Anglais — Musée d'Art Moderne de la Ville de Paris'

Sunday Telegraph 17 June 1979 Michael Shepherd, 'World's Eye View'

Arts Review 6 July 1979 Michael Shepherd, 'Basel Art Fair'

Now 13 December 1979, Illustration of 'Eight of Diamonds'

The Spectator 29 March 1980 John McEwen, 'Taped'

Art and Artists June 1980 Fenella Crichton and Mary Rose Beaumont, 'London'

Notes on the John Moores exhibition November 1980 Marco Livingstone, note on 'Anchorage'

Arts Review 7 November 1980 Michael Shepherd, 'FIAC — Paris Art Fair 1980'

The New York Times 8 May 1981 Vivien Raynor, review of Buckley exhibition at Brooke Alexander

The Observer 13 September 1981 William Feaver, 'Peacocks at a Private View'

Arts Review 25 September 1981 Caroline Collier, 'Stephen Buckley/Knoedler Gallery'

The Spectator October 1981 Matthew Collings, 'Stephen Buckley at Knoedler, Summer Show at Blond'

Los Angeles Times 9 April 1982 S.M., 'Venice' review of the Buckley show at Louver Gallery

Artweek 24 April 1982 Neal Menzies, 'Serenity and Restlessness', review of Buckley at Louver Gallery

Arts Review 27 August 1982 'Artists' new prints at Waddington Graphics'

Liverpool Post 8 October 1982 Philip Key, 'Art in the Balance — up before the hanging judges'

Arts Review 8 October 1982 Mary Rose Beaumont, 'Stephen Buckley/Knoedler Gallery'

Burlington Magazine July 1983 Richard Shone, review of Buckley at Brooke Alexander Gallery

Financial Times 11 October 1983 William Packer, 'In Defence of Fine Art'

The Observer 16 October 1983 William Feaver, 'Albert's New Memorial'

The Spectator 29 October 1983 John McEwen, 'Radiant'

Burlington Magazine November 1983 Richard Shone, review of Buckley exhibition at Knoedler Gallery

other publications

Stephen Buckley. Galleria dell'Ariete, Milan. October 1973. Introduction by Lynda Morris.

Cambridge Works by Stephen Buckley. Kettles Yard Gallery, Cambridge, 16 February-10 March 1974.

The Tate Gallery Biennial Report and Illustrated Catalogue of Acquisitions 1972-4. Entries on **Nice** 1972 and **Trullisatio** 1972 (Richard Morphet).

The Tate Gallery 1974-6: Illustrated Catalogue of Acquisitions. Entry on **Triptych** 1974 (Richard Morphet).

Pictures in the Walker Art Gallery Liverpool (1978). Entry on **Head of a Young Girl no. 1** 1974 (Marco Livingstone).

The Tate Gallery: Illustrated Catalogue of Acquisitions 1980-82. Entries on **Java** 1980 and on **Ten Colour Etchings** 1979-80.

Biography

Stephen Buckley was born in Leicester on 5 April 1944. He attended the University of Newcastle-upon-Tyne between 1962-67, studying under Richard Hamilton, and went on to obtain an M.F.A. at the University of Reading between 1967-69. He taught at Canterbury College of Art in 1969-70 and for two terms in 1970 at Leeds College of Art, and since 1971 he has been a regular visiting lecturer at Chelsea School of Art. Between 1972-74 he was Artist in Residence at King's College, Cambridge. He has been a prizewinner at the Northern Young Contemporaries Exhibition (1968), John Moores Liverpool Exhibition 9 (1974), Chichester National Art Exhibition (1975), Tolly Cobbold Exhibition (1977) and John Moores Liverpool Exhibition 14 (1985). He currently lives in London with his wife, Stephanie James, and his children Scarlet and Felix.

works in public collections

Arts Council of Great Britain
British Council
Tate Gallery
Victoria and Albert Museum
Contemporary Arts Society
Aberdeen Art Gallery
City Art Gallery, Bristol
University of Cambridge, Kettles Yard Gallery
Eastern Arts Association
Walker Art Gallery, Liverpool
Whitworth Art Gallery, University of Manchester
Southampton City Art Gallery
Metropolitan Museum, New York
Museum of Modern Art, Caracas, Venezuela
Australian National Gallery, Canberra, Australia
National Art Gallery, Wellington, New Zealand

commissioned works

1972 Neal Street Restaurant
1972 mural painting for Penguin Books
1973 Leith's Restaurant

84

photograph © Paddy Summerfield 1985.